GEOFF KERSEY'S
POCKET BOOK
FOR
WATERCOLOUR ARTISTS

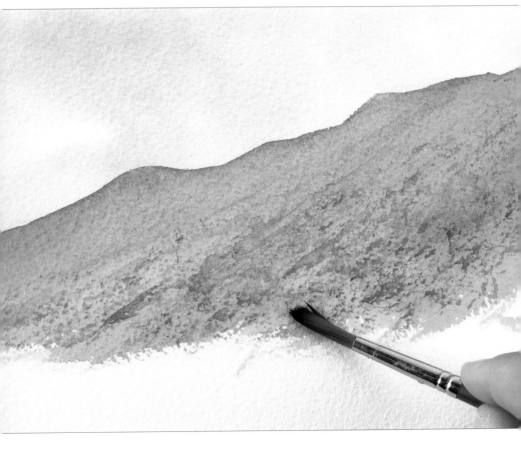

First published in 2010 as *Geoff's Top Tips for Watercolour Artists*

This edition published in 2018

Search Press Limited
Wellwood, North Farm Road,
Tunbridge Wells, Kent TN2 3DR

Reprinted 2020, 2021, 2022

ISBN: 978-1-78221-638-4

The Publishers and author can accept no responsibility for any
consequences arising from the information, advice or instructions
given in this publication.

Suppliers
If you have any difficulty obtaining any of the materials and
equipment mentioned in this book, then please visit the
Search Press website for details of suppliers:
www.searchpress.com

Publishers' note
All the step-by-step photographs in this book feature the author,
Geoff Kersey, demonstrating how to paint with watercolour. No
models have been used.

Geoff Kersey's
Pocket Book
for Watercolour Artists

Geoff Kersey

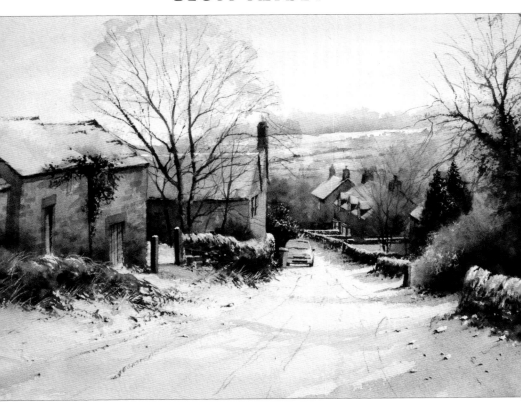

SEARCH PRESS

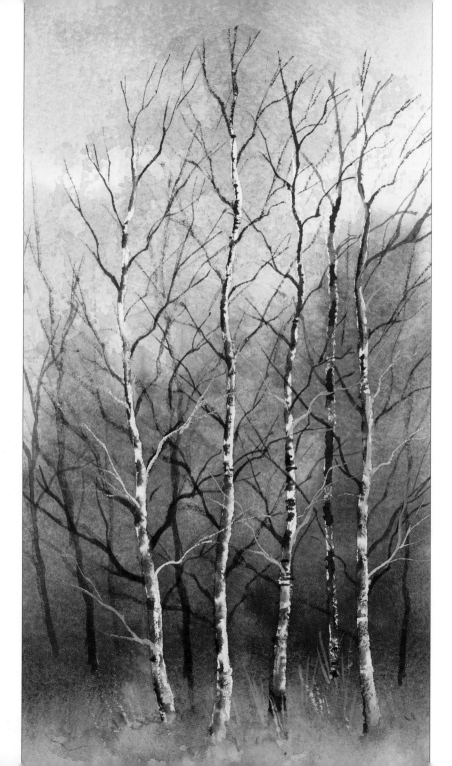

CONTENTS

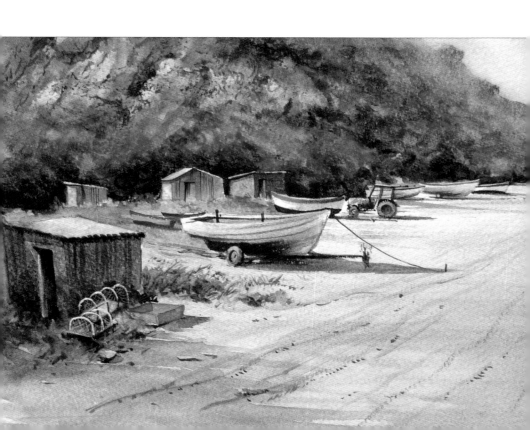

ABOUT THE AUTHOR

Geoff Kersey spent his childhood in Sheffield on the edge of Derbyshire's Peak District, where frequent visits to the countryside for days out and family picnics, led to the love of the rural landscape that now inspires and influences his work.

He trained in Graphic Design and worked in marketing for over twenty years, painting as an amateur, while harbouring the ambition that one day he could paint professionally. That opportunity came in 1998, since when he has divided his time between running painting holidays and workshops, demonstrating, lecturing and writing in addition to painting to exhibit at his studio/ gallery, attached to the home in Derbyshire that he shares with his wife, Florence.

INTRODUCTION

In the years I have spent teaching, I have noticed that one of the most difficult aspects for students embarking on a painting, is actually knowing how to set about it. They usually have a vision of what they would like the finished painting to look like, but do not have a sufficient repertoire of techniques to see it through to a satisfying conclusion. That is my reason for compiling this book of my top tips for watercolour landscape painting.

In putting together these tips, I have tried to cover most of the main techniques and methods I use to create my watercolour landscape paintings. When I was learning (not that you ever stop learning), I gained a lot from looking at the work of artists I admired, and enjoyed trying to work out how certain effects had been achieved. I have endeavoured therefore to make this book rich in information, with full explanations of each technique and method, showing how the tips translate into finished paintings, rather than relying solely on simplified examples.

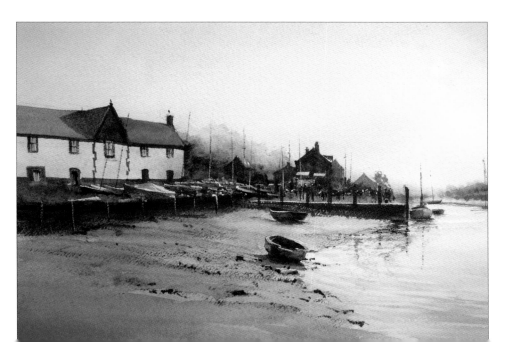

WHAT TO BUY

Paper

Both in terms of ease of use and how it affects the finished result, I think paper is the most significant item on your materials shopping list, and buying the right one pays dividends.

As with all materials, personal preference plays a part, but my recommendation is to avoid the cheaper, wood-pulp papers; instead, look for the description 'cotton' or 'rag' when choosing papers. These are generally a little more expensive but are much tougher and more forgiving. I use masking fluid in most of my paintings and because the wood-pulp papers are weaker, there is always the possibility that the surface will tear when you come to remove it. I have seen this happen time and time again on the various painting holidays and workshops I run.

I mainly use paper with a Rough surface, occasionally selecting Not (also known as cold pressed, which has a bit of tooth or texture, but not as much as Rough) if I am painting a subject with a lot of fine detail. Dry brush techniques (see pages 16–17) are much easier and more effective on Rough paper.

I use two brands, Arches 300gsm (140lb) and 640gsm (300lb) Rough and Saunders Waterford Rough in the same weights. Both these papers are made with 100% cotton, which provides a stronger surface than wood-pulp paper, but the main advantage is that it is much easier to lay a fresh wash over an earlier dried wash without disturbing the previously applied colour.

When you need to stretch paper

If you are using the 640gsm (300lb) paper, you should not need to stretch it, even if you use a lot of water. If you do not stretch 300gsm (140lb) paper, it will probably cockle and curl, thus making it difficult to paint on, and even more difficult to mount and frame, so I always take the time to stretch this type of paper.

The principle behind stretching paper is that it expands when it is wet and contracts as it dries. If you secure it to a painting board in its wet state, then as it tries to contract, it can't, so it tightens up and becomes taut, a bit like a drum-skin. This provides a surface that will not cockle or curl despite getting quite wet during the painting process.

How to stretch paper

2. Apply plenty of water to the gummed side of the tape using a sponge.

1. Always totally immerse the paper. Do not soak it for too long: one minute in the water is plenty. After immersion, leave the paper on the painting board for a few minutes before securing it. This allows it to expand. If you are securing it with gummed tape, dab the wet paper around all four edges with kitchen paper before applying the tape. This causes the edge to dry more quickly underneath the tape, which then gets a grip before the whole sheet starts to dry and contract.

3. Use the tape to stick the paper to the board and leave it to dry.

An alternative to tape is a staple gun. I use one of these all the time as it is quicker and works every time. A cautionary note though; it does not work on the cheaper wood-pulp papers because they generally tear through the staples during the drying process.

Brushes

Like all materials, the choice of brushes divides opinion, and ultimately you need to find what you prefer, and what best suits your style of painting. I personally think you do not need to spend a great deal to get a good quality brush. I prefer synthetic brushes, as I like the springy quality which ensures that as soon as you lift the brush off the paper, it returns to its shape. Synthetic brushes do not absorb as much water or paint as natural hair like sable or goat, and the advantage of this, especially when you are learning, is that less water or paint on the brush can make it easier to control, helping to avoid flooding or creating 'cauliflowers'. The one exception among my collection of brushes is the extra large oval wash brush that I use for skies. This is part squirrel, part nylon, which gives an extra absorbency, useful for covering a large area quickly.

I have four flat brushes, a 2.5cm (1in), a 13mm (½in) and a 6mm (¼in). I also use no. 2, 4, 6, 8, 10 and 16 round brushes, a liner/writer, an extra large oval wash brush and a rake brush (right).

Brush care

The point is the most important part of the brush. It is much more difficult to make the exact mark you want, in the exact place you want to make it, if the point is not in good condition. If you frequently use the dry brush technique, you will find that the point of the brush wears quickly, so it is a good idea to keep old, worn brushes for this purpose.

Do not carry your brushes around in anything that does not protect the points. If the hairs become bent, especially while they are wet, they will stay bent forever.

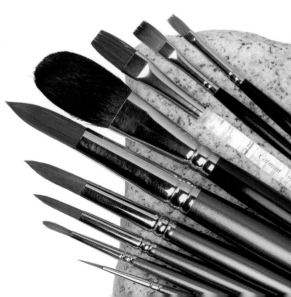

Paints

I have a field set of watercolour pans (right) that is very compact, making it ideal for outdoor sketching and quick studies, which I can use as sources of information for later studio work. However, apart from this, I do all my paintings with tube colour, as I prefer the rapid way you can mix plenty of fluid wash. Tube paints enable you to vary the consistency quickly and easily, because the paint comes out of the tube already halfway to liquid.

There are numerous brands of paint, and again people have various loyalties and preferences, based on what they are familiar with, and what suits their work. The main difference is whether the paint is artist's quality or student's quality. Artist's quality watercolour is approximately three times the price of the student's quality; depending on the colour, the difference can be even greater. I always use artist's quality paint and believe it is worth the extra expense. I trust the artist's colour more and find the student's quality can be a false economy, because it has a greater ratio of gum to pigment, so does not go as far.

Keep your paints moist

At the start of a painting session, I top up the paint in my palette, and at the end, I put a piece of wet paper tissue over the neat paint and close the palette lid. This keeps the paint moist for several days. Do not let your paints dry out; you can revive dried up paint with water, but it is much easier to use and gives a much better result when it is fresh and moist.

Other materials

Water pot

I use the collapsible or 'lantern' type of water pot, because I carry a lot of equipment around and they are light and compact. Any type of old jar will suffice, but choose a large one, or you will be changing the water every few minutes.

Kitchen paper

A really useful material, not only for keeping everything clean, but useful for creating textured effects. See Stonework, page 21 and Tumbling water, page 64.

Masking tape

This can be useful in situations when you want to mask a totally straight, neat line like the sides of tall buildings or the horizon line on a seascape. You need to experiment with different brands, as some are too sticky and damage the paper, whereas others are not sticky enough and let the paint seep underneath. Masking tape cannot be used to stretch paper as it will not adhere to a wet surface; for this purpose gummed tape is the best product. See How to stretch paper, page 9.

Mechanical pencil

I find these very useful as they avoid the need for constant sharpening. I use three different gauges, a 0.5mm, a 0.7mm and a 0.9mm depending on what I am drawing. This type of pencil usually comes with HB leads, which I find a bit hard, so I buy 2B leads to replace them.

Hairdryer

I only use a hairdryer when I am in a hurry, for instance in a demonstration situation. However it can be useful if you are painting wet into wet and you consider the paint has spread just far enough and want to dry it immediately to prevent it spreading further.

Masking fluid

I use this to varying degrees on nearly every painting. There are a lot of different brands on the market. Colourless masking fluid can be more difficult to use because it is not easy to see where you have put it, so you might prefer the blue tinted type. Keep the cap on firmly, as masking fluid deteriorates quickly if air gets to it. Ordinary soap is used to protect your brushes. See pages 22–23.

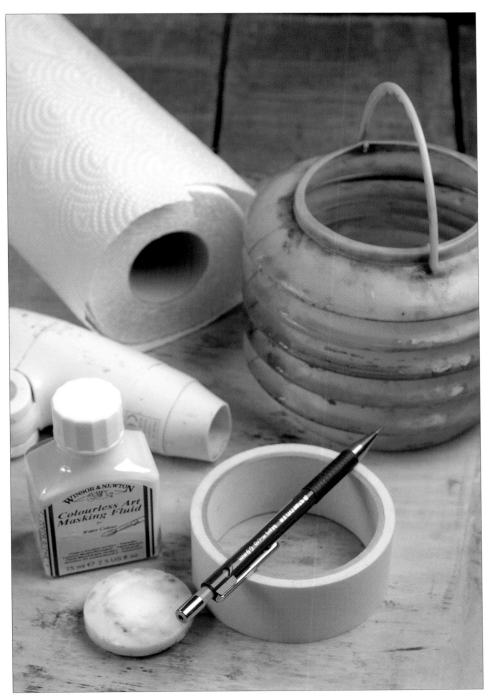

TECHNIQUES

Wet into wet

This involves applying wet paint to a wet background, to create a soft-edged effect. When you place a colour on a wet background, you dilute it, thus lightening it, which can be a problem if it is not strong enough in the first place. Always put the first few marks in tentatively with the point of the brush, watching the results closely. If the colour spreads rapidly, you will lose control of the shape; if this happens, wait a few moments for the paper to get a bit drier, and then work rapidly before it becomes too dry. Timing is vital with this technique.

Wetting the paper

The best way to wet a large area of paper is using a natural sponge. It is quicker than using a brush and easier to judge how wet you are making the paper, so it helps you to avoid overwetting it, and ending up with puddles of paint.

Wet into wet fir trees

1. Mix your washes before beginning. Wet the paper. Drop in cobalt blue using a no. 12 brush.

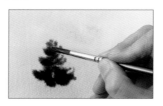

2. While the blue is still wet, paint in the fir tree shape with a mix of aureolin, ultramarine and burnt sienna, using a brush with a fine point.

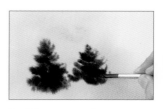

3. Paint a second tree quickly while the background is still wet.

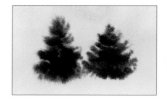

The finished fir trees are soft-edged, with no hard lines.

Wet on dry

This method is ideal for depicting a wintry sky with horizontal stratus cloud formations. It only works if the first wash is totally dry before commencing the second stage.

A wet on dry sky

1. Paint a thin wash of Naples yellow over the whole paper using the no. 16 brush. Allow it to dry.

2. Mix ultramarine with a little burnt sienna and use the no. 12 brush to paint streaks across the dried background. Painting wet on dry in this way creates harder looking lines.

3. Continue painting streaks of cloud. You can soften some of the edges with a damp, clean brush, to vary the effect.

Dry brush work

Use a thick mixture of paint. Hold the brush handle with your thumb at one side and your finger at the other, lay the flat of the brush on the paper and apply paint very sparingly, just catching the raised texture of the paper. Using Rough paper helps.

Creating texture on hills

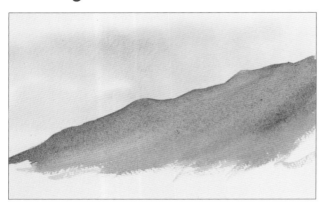

1. Paint the sky with a wash of cobalt blue, then allow it to dry. Paint the hill from the top, with a grey mix of cobalt blue, rose madder and burnt sienna. While this is wet, brush in a sandy mix of Naples yellow and light red. Lower down, still working wet into wet, brush in raw sienna and burnt sienna. At the bottom, drop in a green mixed from aureolin and cobalt blue. Allow to dry.

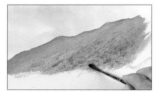

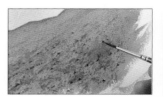

2. Wash the no. 7 brush and dab it on kitchen paper to remove excess liquid. Pick up a light grey mix of cobalt blue, rose madder and burnt sienna. Hold the brush flat against the paper and paint streaks on the dried background.

3. Pick up a darker grey mix of cobalt blue and burnt sienna and apply this in the same way. Allow to dry.

4. Using the dark grey mix on a no. 1 brush, develop some of the marks created with dry brush work into stones and other bits of texture.

The finished textured hillside.

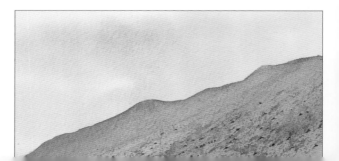

Painting foliage using dry brush work

 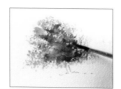 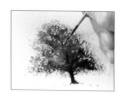 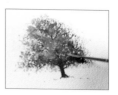

1. Draw a rough tree outline. Use the no. 7 brush on its side to paint on a bright green mix of aureolin and cobalt blue, just catching the surface to create a broken effect.

2. Use a no. 4 brush and a dark mix of aureolin, ultramarine and burnt sienna to suggest the shaded foliage. The smaller brush prevents the dark colour from overwhelming the brighter green.

3. Put in the trunk and glimpses of branches with the no. 1 brush and a thick mix of burnt sienna and ultramarine. Allow to dry.

4. Still using the no. 1 brush, paint a few highlights with neat lemon yellow.

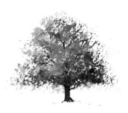

The finished tree.

Dry brush work on snow

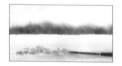 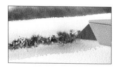

1. Paint the sky and wet into wet trees in the background. Use the no. 4 brush to drag a mix of raw sienna and burnt sienna across the paper surface.

2. Before this dries, paint on a darker mix of burnt sienna and ultramarine in the same way.

3. While the paint is damp, use the blade of a craft knife to scratch out grasses.

4. Paint more twigs and grasses with the no. 1 brush and a mix of burnt sienna and ultramarine.

5. Paint a cast shadow from the undergrowth with the no. 7 brush and cobalt blue with rose madder.

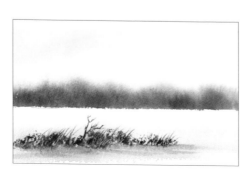

The finished snow scene.

Other techniques

Fading colour

This demonstration shows how you can take some of the colour out of the hill painted on page 16, to enhance the effect of distance.

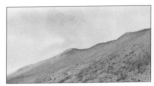

1. Use a damp brush to paint clean water on to parts of the hard edge on the furthest part of the hill.

2. Rub the area gently with a paper tissue.

The finished hillside. Fading some of the colour gives it a misty, distant look.

Using a natural sponge for foliage

1. Lightly dab on an orange mix of aureolin and burnt sienna to create the tree shape.

2. Without cleaning the sponge, pick up a redder mix of raw sienna and burnt sienna, and dab this on.

3. Dab on a dark mix of burnt sienna and ultramarine for the shaded side of the tree.

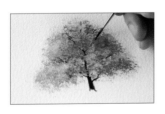

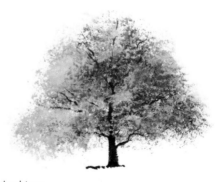

4. Paint the trunk and branches using a no. 1 brush and the same dark brown mix.

The finished tree.

Creating low cloud and mist on mountains

The painting at the bottom of page 46 was created using this method. Before beginning on the mountains, you will need to mask the waterline, then paint the sky and let it dry. Then mix a blue from cobalt blue and rose madder and a grey from cobalt blue, rose madder and burnt sienna, ready to work quickly wet into wet on the mountains.

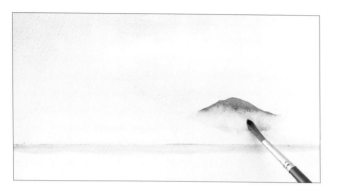

1. Paint the top of the mountain with the blue mix, then drop in a touch of grey below this. Soften the lower edge with clean water.

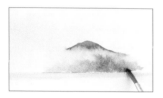

2. Paint more grey lower down, then more clean water, then brush in raw sienna and burnt sienna by the waterline.

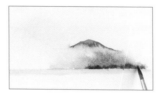

3. At the water's edge, paint a dark mix of burnt sienna and ultramarine. Allow to dry.

4. Paint a larger mountain on the left in exactly the same way, with blue at the top, then grey, then clean water, then raw sienna and burnt sienna, and finally burnt sienna and ultramarine by the waterline.

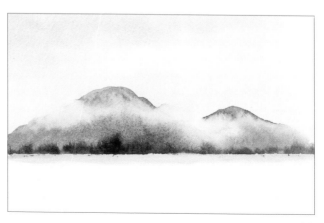

Creating weathered wood using a rake brush

Paint the shed using a grey mix of burnt sienna and ultramarine. Allow to dry, than paint the roof with raw sienna and burnt sienna, and add shade under the eaves with the same grey. Use the rake brush with a thick, dark mix of burnt sienna and ultramarine to paint downward strokes, creating the texture of woodwork. This technique was used in the painting *Port Mulgrave* on page 67.

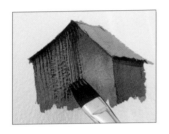

The finished shed.

Painting foliage with the rake brush

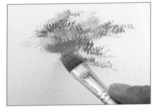

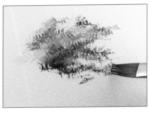

1. Apply lemon yellow with dabbing strokes of the rake brush. Keep changing direction to create a natural look. Then repeat with a bright green mix of aureolin and cobalt blue on top.

2. Apply a dark green mix of cobalt blue, aureolin and burnt sienna on top, in the same way.

3. Finally, dab on more lemon yellow for highlights, making sure you change the angle of the brush to keep the foliage natural looking.

Stonework

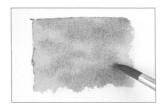

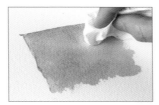

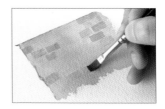

1. Use the no. 12 brush to paint on raw sienna and burnt sienna, then randomly drop in a mix of cobalt blue and rose madder wet into wet. Then drop in a green mixed from aureolin and cobalt blue.

2. While the paint is still wet, dab it with kitchen paper to create texture and a weathered look. Allow to dry.

3. Mix together the first two washes and use the 6mm (¼in) flat brush to paint horizontal dashes to represent stones. Vary the paint mix and add some of the green in places.

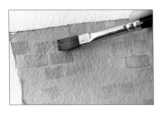

4. Clean the brush and dab it on kitchen paper. Pick up the same grey paint mix and take most of it off on kitchen paper so the brush is very dry. Paint some more stones with the dry brush to create texture.

5. Use a no. 1 brush and a dark mix of cobalt blue and burnt sienna to suggest crevices. Do not paint round every stone.

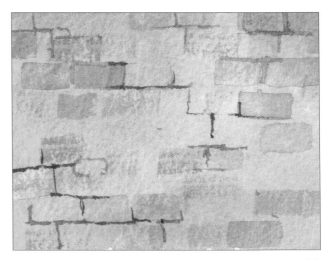

The finished stone wall.

USING MASKING FLUID

Every time I start work on a new painting, masking fluid is an early part of the process. Once I have drawn the subject on to the watercolour paper, I consider where I want to put masking fluid, based on areas I know I need to keep white paper for later on; to me this is a vital part of the planning and design of the painting.

Here are a few tips that should help you to use masking fluid effectively, without disasters.

Protect your brush

Before applying the masking fluid, dampen the brush and rub it on a piece of soap; this acts as a barrier and helps prevent the brush getting gummed up. Never use an expensive brush to apply masking fluid; sooner or later it will ruin it. I use purpose-made masking fluid brushes in different sizes, but any inexpensive brush will do the job, so long as it still has a reasonable point.

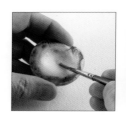

Apply masking fluid carefully

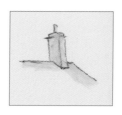

Apply masking fluid with the same care you would take to apply paint. If you are a little careless with the masking fluid, you will find when you remove it that the white area underneath does not bear much relation to the shape you intended.

Do not leave masking fluid on the paper too long

It can become difficult to remove. If you have to stop working on a painting and will not be coming back to it for several days, I suggest you remove the masking fluid and reapply it when you continue.

Drying and removing masking fluid

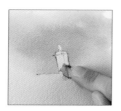

Avoid using a hairdryer to dry masking fluid, as the heat can make it stick fast to the paper. You might get away with it, but is it worth the risk? The best way to remove masking fluid is with the tip of a clean finger.

Masking detail

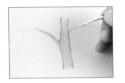 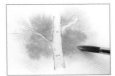 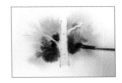 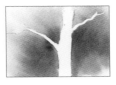

1. Apply masking fluid to the tree carefully, using a fine brush.

2. Wet the background and drop in cobalt blue, then a mix of aureolin and cobalt blue.

3. Drop in a dark green mix of aureolin, ultramarine and burnt sienna.

4. Allow to dry and remove the masking fluid to reveal the detailed shape.

Masking fluid on a wet background

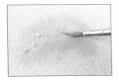 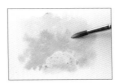 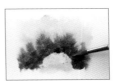 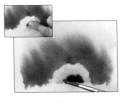

1. Wet the paper, then float in the masking fluid to create a soft-edged shape for a bush. Allow it to dry.

2. Wet the background again and float in cobalt blue for the sky, then aureolin and cobalt blue around the masked bush.

5. Pick out a few leaf shapes using neat lemon yellow and a fine brush.

3. Drop in a mix of ultramarine, aureolin and burnt sienna to create a dark contrast with the bush. Allow to dry.

4. Rub off the masking fluid. Drop in lemon yellow, then aureolin and cobalt blue, then aureolin, ultramarine and burnt sienna.

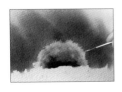 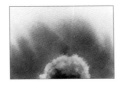

The finished bush.

Masking the horizon

 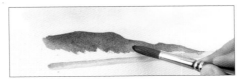 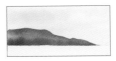

1. Draw the horizon with a ruler, making sure it is level, then mask beneath it with a broad line.

2. Wet the sky area and paint it with cobalt blue. Allow to dry. Paint the hill with cobalt blue, rose madder and burnt sienna. Make the colour more intense where it meets the masking fluid. Allow to dry.

3. Remove the masking fluid. Do not worry if the line is not perfect, as this makes it look more natural.

23

MIXING COLOURS

When you start painting, one of the most difficult things to decide is which colours to use. There is a vast array of colours available to us today. In a range of watercolour paints by just one manufacturer, I recently counted over twenty different tubes of yellow and fourteen of blue, from a total of almost a hundred shades. It is great to have all this choice and I do advocate experimenting with different colours from time to time to see what new dimensions they can bring to your work. However, you really need to learn how to mix colours to achieve the result you are looking for, and it is incredible how many subtle nuances of tone and shade you can achieve using a limited palette from just a few tubes.

Using a limited palette

On these pages I have set out the basic colour palette and combinations I use for most of my landscape paintings.

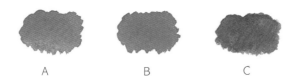

A B C

A **Cobalt blue** My favourite blue for skies. You can use it with just water.

B **Cobalt blue and rose madder** For skies and shadows. The addition of rose madder warms the blue.

C **Cobalt blue, rose madder and burnt sienna** For grey skies and cloud shadows. The addition of burnt sienna greys the mixture.

D

D **Neutral tint** A cooler grey. Good for heavier, more dramatic skies.

E

E **Naples yellow** A subtle yellow. Takes the white off the paper in skies.

F

F **Naples yellow and vermilion** Ideal for putting a warm glow in the sky.

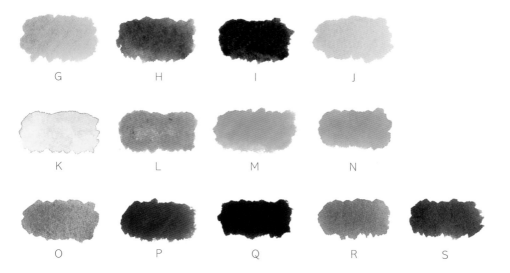

G **Aureolin and cobalt blue** A spring/summer green. The bluer the mix, the darker the green becomes.

H **Aureolin, French ultramarine and burnt sienna** A darker, more olive green.

I **Viridian, French ultramarine and burnt sienna** A rich, dark green, good for shadows in dark foliage.

J **Raw sienna** A warm yellow, perfect for autumn foliage and stonework.

K **Quinacridone gold** A very powerful, transparent, glowing colour. Occasionally I use it in skies and to make greens. Use it with caution as it can be overpowering.

L **Raw sienna and burnt sienna** This is very warm and makes good autumn foliage, brickwork and rust.

M **Lemon yellow and burnt sienna** This is slightly brighter and is also great for autumn foliage.

N **Aureolin and vermilion** A rich, warm red. I use this for pan-tile roofs, which look great against a blue sky.

O **Raw sienna and cobalt blue** The blue cools the raw sienna and gives it a slightly green hue. Good for stonework.

P **Burnt sienna and cobalt blue** A medium brown that makes good winter darks.

Q **Burnt sienna and French ultramarine** This is probably the darkest combination in my palette, used for winter darks and architectural detail, twigs, branches and lots more.

R **Cobalt blue and viridian** Sea blue, probably more suitable for depicting a warm Mediterranean sea.

S **Cobalt blue, viridian and burnt sienna** The burnt sienna greys the colour. This colour is suitable for cooler seas, or shadowed sea areas.

THE IMPORTANCE OF SHADOWS

In many of the tips in this book, I have touched on the influence of shadows. However I believe shadows are so fundamental to putting reality into your paintings, that we need to go into the subject in detail.

Using shadows to describe shapes

Consider how you can use shadows to describe the shapes of objects. For instance note how I have used shadow here to describe the cylindrical nature of the tree trunk. The best way to do this is to apply the light colour, then while this is still wet, apply the darker shadow colour to the shaded side, allowing the colours to merge gradually towards the middle of the trunk. Before it dries, touch in a bit more of the darkest colour at the very edge of the shaded side to increase the difference between the lightest and darkest colours. The key to making a success of this is the gradual change of tone from dark to light.

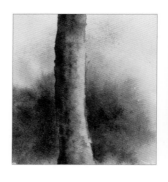

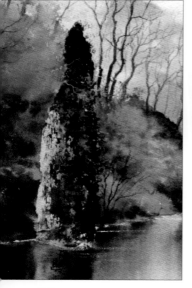

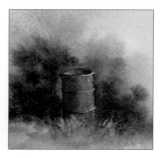

The same principle applies to this oil drum, but here the blend of colours is smoother, giving the impression of painted metal, as opposed to the rough texture of bark. Notice how I have indicated a glimpse of the interior of the barrel by reversing the shadow.

Here is another example of using shadows to create the shape, *Pike's Pool, Hartington*. The shadowed side is much darker than the light side and is applied using the dry brush technique on Rough paper. Try and find an opportunity to contrast the light side with the dark behind it, and the dark shadows with the light behind (see the top of the pike).

The colour of shadows

A good rule of thumb for the colour of shadow is that it is a darker version of the colour over which it is cast; for example shadow on a field of green would be a darker green; shadow on light brown would be darker brown. Having said this, try to look for opportunities to use a warm purple/blue shadow on white or yellow/orange backgrounds, as it can give the painting a feeling of warmth. This is especially effective in an autumn scene if you contrast the purple with autumn golds and oranges (see page 55) because these colours are opposites and really contrast with each other, giving the painting vitality and punch.

In figure 1 I have glazed a thin wash of cobalt blue mixed with rose madder over the shadowed wall of the building, adding just a touch of raw sienna mixed with burnt sienna at the base of the shadow to give the impression of reflected light. When adding a shadow like this, use the blue from the sky in the wash, in this case cobalt blue.

In figure 2 the basic colour of the building is a warm yellow/brown (raw sienna with a touch of burnt sienna). This works equally well with the glazed purple shadow.

Figure 3 has the same warm sandstone colour on the walls, but this time the shadow is a darker version of this base colour, a brown mixed from burnt sienna and cobalt blue. I think both work well; ultimately it is up to you.

figure 1 *figure 2* *figure 3*

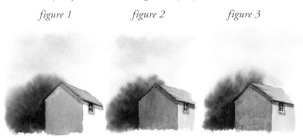

Adapting the shadow colour to the background

You can change the colour of shadows as they progress across the landscape. In this case the shadows are dark green across the lighter green grass, changing to a warm purple colour when crossing the autumn leaves and the path, reverting to dark green again as they continue across the lighter green at the opposite side. Strong shadows like the ones in this painting work well, but they should still be transparent.

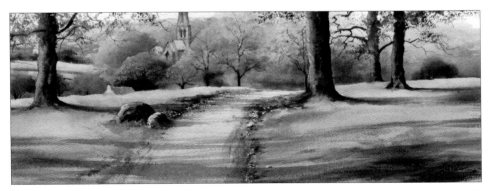

Using shadows to make buildings convincing

In this painting, *One Ash Grange, Derbyshire*, I have made these buildings appear solid and three-dimensional by careful use of shadow. The basic colour of the stone is a warm orange/brown, so I chose a purple tint for the shadow, mixed from cobalt blue and rose madder, which echoes the colour in the sky. Before attempting shadows, make sure the colour underneath is completely dry. Always look for an opportunity to bring the sky colours into the shadows; it gives the painting consistency and harmony.

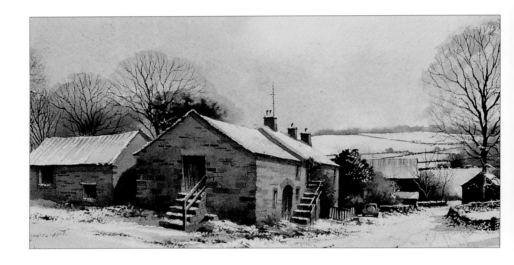

I have used shadows to create the hard corners where the wall in the light meets the wall in shadow; a good idea is to make the

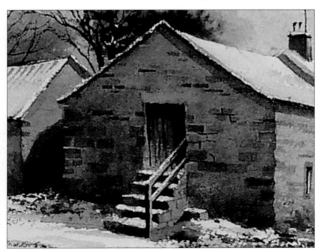

shadow slightly darker at the corner, to increase the contrast (see close-up, left). You should make good use of shadows on smaller details as well; look at the rows of steps and note how the light illuminates the sides and tops of the steps, with the drops in deep shadow. Use strong shadows to give the impression that windows and doors are recessed. Always look for little details, like the way the main barn casts a shadow on to the illuminated side of the barn on the far left.

Looking into the light

In this type of scene we are looking into the light, which makes the trees dark silhouettes and the shadows quite strong colours. Even when you are using quite strong tone for your shadows, keep them transparent, as it is important that the viewer can see the colours underneath. Make the shadow darker, nearer to the item casting it; you can see this from the base of the trees in this example.

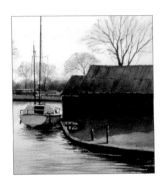

Dark shadows

Don't be afraid to make your shadows quite dark, but then look for an opportunity to contrast this with a patch of bright light. As you can see from this detail, from a painting called *Winter's Afternoon, Norfolk Broads*, it is not clear where the bottom of the shed wall ends, and the shadow starts, but as the shadow progresses across the patch of winter grass, it is transparent. Remember darks do not have to be opaque.

Using shadows to describe the shape of the land

Shadows present us with a priceless opportunity to describe the contours and shapes of the landscape. What do the shadows tell us about this scene? The light is coming from the right. The farthest trees appear much finer to reinforce the perspective, so their shadows should also be finer. Warm colours come forward and cool colours recede, so make your foreground shadow warmer by adding a touch more of whatever red/crimson you are using. The shadows slope down the right-hand bank, then proceed horizontally across the flat road before sloping up the left bank, describing the contours of the landscape. Try to reserve your strongest shadow for the foreground, as it brings this forward and, as in this case, can make the middle distance look brighter.

INTERPRETING PHOTOGRAPHS

While painting outdoors can be very enjoyable and is an excellent way of learning to loosen up and make bolder statements, working from photographs is often much more convenient and can vastly increase the amount of time available to paint. Photographs are an excellent source of information, but it is important not to follow them too slavishly. Before commencing a painting, take a bit of time to look at the photograph and think about what you might want to change. Think about anything you could leave out to simplify the scene and consider anything you want to move to improve the composition or any colour changes you think may improve it.

Always go for atmosphere over accuracy. If you are inspired by a particular scene, and you photographed it, don't wait long before tackling it as a painting. I usually get a much better result if I get started while the atmosphere of that particular day is fresh in my mind.

If as you progress with the painting, you find you are relying on the photograph less and less, which is good – you are now turning it into a painting.

If someone says your paintings look like photographs, they may well mean it as a compliment but it is not. It usually means you are actually copying the photograph rather than using it as an inspiration and/or source of information.

Cutting out clutter

In this example, *Boats at Matlock Bath*, I have left out the foliage across the top of the scene, as it obscures the view, and omitted the plastic storage box and awning on the left. One disadvantage of photographic reference is that dark, shadowy areas can just print out black, giving you no detail; note how I have lightened the right-hand side showing the grassy bank and its reflections. Don't be afraid to use your imagination.

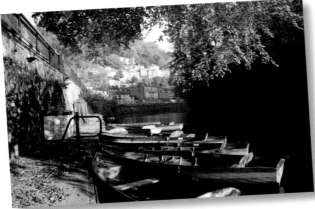

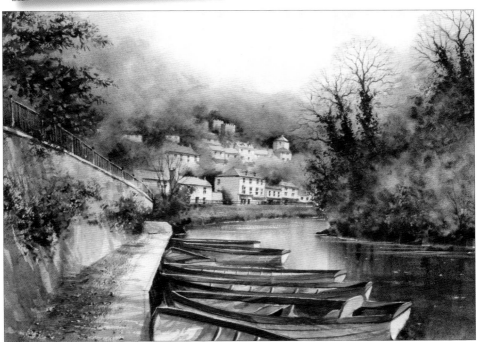

Devise your own colour scheme

Don't slavishly follow the colours on your photograph – use artistic license and imagination. In this example, the photograph is very green and the darker greens are quite blue, with the result that it looks a bit cold. In the painting I have introduced some raw sienna into the foliage to break up the masses of green and add a touch of warmth. Where you have large grey areas like the rock formation, try and add a warm colour like the purple/blue I have brushed into the rocks here.

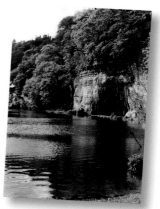

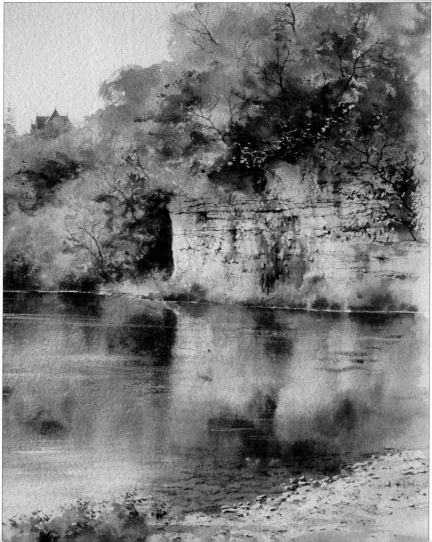

Look for an opportunity to introduce a warm colour to the foreground, like the patch of burnt umber just under the water.

Use a touch of opaque colour (in this case lemon yellow) to indicate brightly lit leaves and break up the solid, dark areas.

Changing the format and editing

How many times do you take a photograph with a view to doing a painting from it and later on wish you had included a bit more of the scene to the left or the right? Remember, photographs are all about gathering information; the more you record at the right moment, the better. To avoid this disappointment, take plenty of each potential subject.

As you can see from this example, I often make a panoramic picture by joining photographs. You can get software to join them seamlessly, but I just print them out and tape them together. You can then study the panorama, decide where to frame the scene, and what to include or leave out. In this example I have used most of the scene in my composition, mainly just editing a bit at the left-hand side. Vary the format you use to change the shapes and sizes of your finished paintings; in this case I chose to use a longer format, with the length roughly twice the depth – the more usual format is for the length to be one and a half times the depth.

Other changes I have made include warming and brightening the colour on the wall of the cottage, moving the old market stand to the right, so it does not obscure part of the cottage, adding a couple of figures on the far right, using a bit more sky and a bit less foreground to improve the composition, and changing the colour of the door, as on the photograph
it is too similar to the colour of the grass.

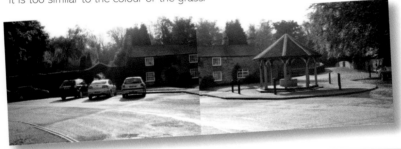

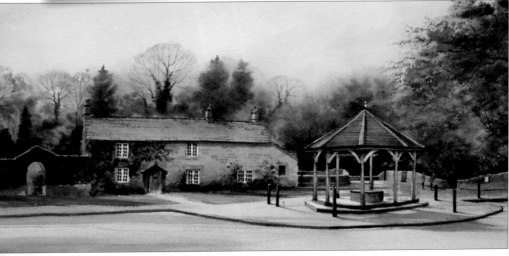

Painting from an unpromising photograph

When I took this photograph of the Norfolk Broads, it was a late winter's afternoon with the light fading fast, so I knew I would have work to do to make a painting of it. The two main boats were more or less the same distance away from me, so I moved the right-hand one nearer to the foreground to improve the composition. The bow of the boat on the far right was neither in, nor out of the picture, so I decided to leave it out altogether. Always look at any area that needs simplifying; I removed a lot of clutter from the left of the left-hand bank and the middle distance, leaving out the cars. Keep reminding yourself of the importance of using tone to give a feeling of distance; here I made the winter trees progressively paler as they receded into the distance. The photograph does not always do that for you.

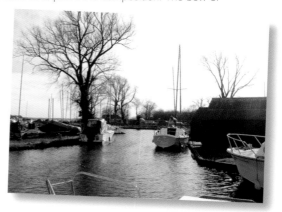

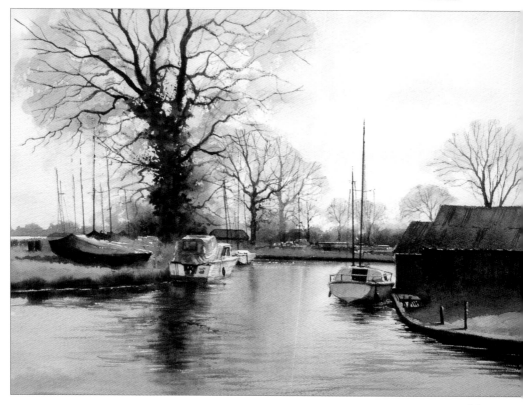

PAINTING SKIES

I decided to write about skies early on in this book because I believe, when it comes to landscape painting, the sky is the key element, as it sets the whole tone and atmosphere for the picture. It is always the first part of the scene that I paint and I still approach it with a certain amount of apprehension, because, despite all the years that I have been painting, there is always a chance it will go wrong. It is this slight unpredictability that can make painting a watercolour sky quite exciting when it goes well, but very frustrating when it does not. If you have already tried watercolour skies, you will know exactly what I mean.

I very rarely choose to paint a scene with a bright, cloudless summer sky as this does not inspire me, so in this chapter I have tried to concentrate on skies that I believe are more interesting, and set the scene with a bit of drama.

The best tip I can give you for painting skies is to practise, practise, practise. Use the colour schemes and methods in this chapter, and then experiment with variations on these themes to create different colours and effects.

Mix all your washes before beginning a wet into wet sky

As with all wet into wet work, it is essential to have a plan in mind and have all your colours mixed and ready before wetting the background.

Angle your painting board

A good tip when painting a wet into wet sky is to have the board at a slight angle. I usually achieve this by supporting the top edge of it with something like the masking fluid bottle.

Lighten the sky towards the horizon

This helps to create that vital feeling of distance. You can see from this example, *Borrowdale, Lake District*, that the heavier cloud formations and darker colours are at the top of the sky, gradually becoming lighter lower down behind the hills.

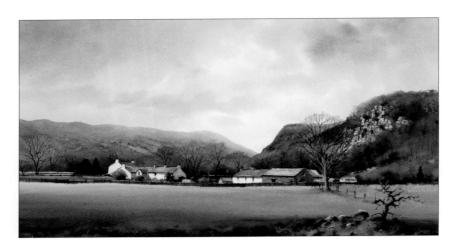

Do not overwork the sky

It is so easy to overwork skies. In all the teaching I have done, I have rarely seen a sky improved by adding just that bit more. In fact I sometimes feel like taking the brush from people! I find it a good practice to work rapidly, then walk away and leave it to dry. During the drying time, the sky continues to develop with a subtle blending of the colours.

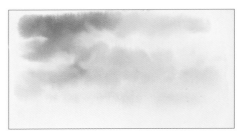

1. Here I wet the sky with clean water, then floated in a mix of Naples yellow and vermilion lower down. Then I painted cobalt blue and rose madder higher up, leaving gaps. Finally, still working wet into wet, I painted clouds from the top with neutral tint and rose madder, and smaller clouds lower down. At this point I stopped painting and left the sky to dry.

2. This photograph shows the same sky after it had dried naturally. You can see that the colours have continued to spread, merge and soften during the drying time, and this look was achieved by leaving the sky alone at the end of step 1.

Masking out the sun

You can mask out a perfect circle to represent the weak winter sun, briefly glimpsed through a fleeting gap in the clouds. You can use a small cork, the lid of your masking fluid, or any cylindrical object, dipped in masking fluid and then printed on to the paper. It is worth practising on scrap paper to establish the amount of masking fluid, and pressure, required to achieve a perfect circle.

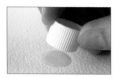

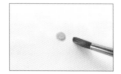

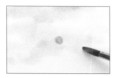

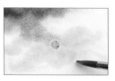

1. Tip some masking fluid into a dish and dip the top of the lid into it. Stamp it on to your paper and leave to dry.

2. Wet the sky with clean water. Paint a mix of Naples yellow and vermilion over the whole sky with the no. 12 brush.

3. Working wet into wet, paint cobalt blue and rose madder from the top of the sky.

4. Paint clouds using neutral tint and rose madder, making them darker at the top and brushing them gently over the masked sun. Allow to dry.

5. Rub off the masking fluid. Fade the edge of the sun a little using clean water.

6. Paint a thin wash of neutral tint and rose madder over the sun to suggest drifting cloud.

7. Dab a little colour out with kitchen paper to create a soft, white edge to the sun.

The finished sky.

This wintry sky was painted in the same way. The simple silhouettes were painted with the same grey as the sky.

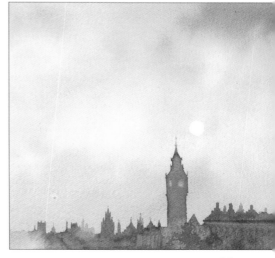

39

Designing the sky

Don't be afraid to use a bit of imagination when creating a sky. In this example (*St Benet's Abbey*, on the Norfolk Broads) you can see that when I took the photograph, it was a summer's day; however I thought this scene would make an excellent winter subject, so I just used my photograph for information, mainly about the structure of the building, and created a sky out of my head. I recommend this, because if it works, it is very satisfying.

I mixed a thin wash of Naples yellow with rose madder, followed by a stronger mix of cobalt blue and finally an even stronger mix of neutral tint with just a touch of rose madder. Using the wet into wet technique and an extra large oval wash brush, I concentrated the darkest and heaviest clouds at the left-hand side, to give me a strong contrast with the light on the stonework and brickwork of the ruined buildings. I employed lighter brush marks with paler colour as I progressed towards the right-hand side of the sky, deliberately making smaller marks towards the horizon to indicate distant clouds, and allowing more of a glimpse of the Naples yellow and rose madder wash.

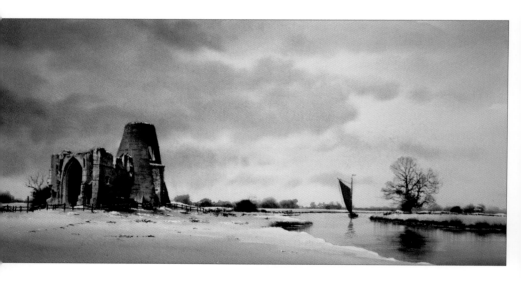

A wet on dry sky

In this example I mixed a wash of Naples yellow before wetting the whole of the sky area with a sponge. I brushed in the Naples yellow with a no. 16 round brush, leaving a small area of clear water approximately in the centre. When this was totally dry, I mixed a thin wash of French ultramarine with just a hint of burnt sienna to grey it slightly, and painted thin streaks across the sky using a no. 10 brush. Before this dried, I cleaned the no. 10 brush, charged it with clean water and used it to soften a few of the hard edges, deliberately leaving others untouched. It is the mixture of hard and soft edges in the streaks that makes this sky interesting.

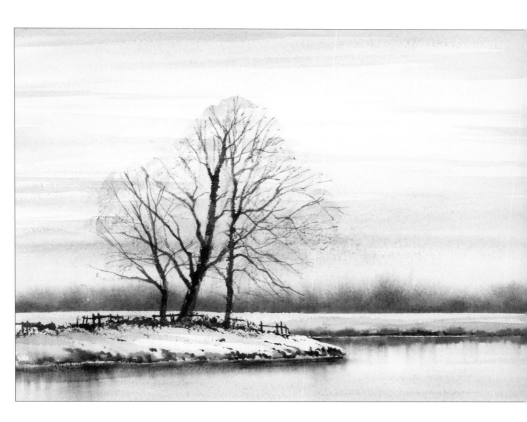

Painting a sunset

To capture the warm, glowing colours of a sunset, I used several washes: raw
sienna; rose madder; cobalt blue; and a purple/grey mixed from cobalt blue, rose
madder and burnt sienna. After wetting the paper I laid these washes in with a
no. 16 round brush, using horizontal strokes that sloped slightly upwards towards
the right. This slope should be very slight; if the angle is too steep, it looks odd.
I started with the raw sienna for the lower part of the sky, before introducing the
rose madder, painting it right to the top, and then the cobalt blue. Allow the blue to
mix with rose madder on the paper to create a warm purple/blue colour, but avoid
mixing the blue in with the raw sienna, as it could turn green. While these colours
were still wet, I put in the purple/grey mixture, making thinner strokes towards the
horizon and larger shapes towards the top.

Once the sky had dried, the hills were put in with various strengths of the purple
grey, to aid the feeling of distance (see the example on page 44 in the Hills and
mountains section).

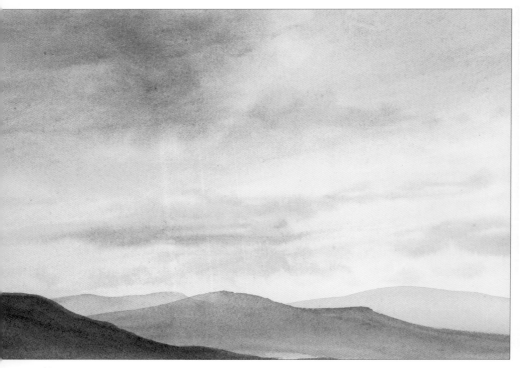

Use the sky colours throughout the painting

It is important to bear in mind that the sky should not be seen as a separate entity; it affects the whole of the landscape. This is best achieved by echoing the sky colours throughout the scene, bringing harmony and consistency to the painting.

In a low-light situation like this (*Evening at Burnham Overy, Norfolk*), the warm glow in the sky affects every aspect of the landscape. Notice how this warm colour, mixed from quinacridone gold and rose madder, is reflected in the whitewashed wall and roof of the building on the left and also the sand and mud of the beach. The grey colour at the top of the sky, made by adding a mixture of cerulean blue and rose madder, suffuses the shadows and darks.

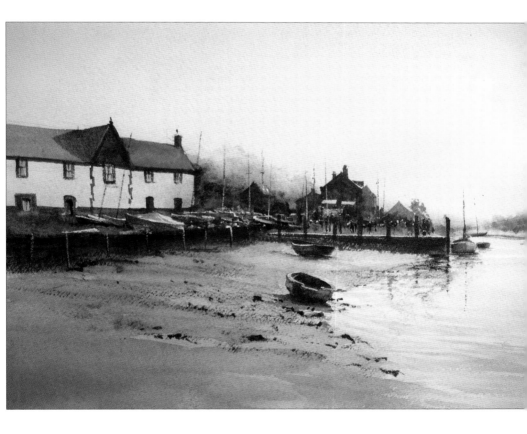

PAINTING HILLS AND MOUNTAINS

No watercolour landscape book would be complete without a chapter devoted to capturing this very special type of scenery.

Creating distance

In this painting of Brotherswater in the Lake District, I started painting the distant hills with the same grey mixture as used in the sky. You can see how I have made the distant hills recede by painting them much lighter in tone than the middle distance and foreground. Always work from the background forward, gradually strengthening the tone and introducing warmer and brighter colours; this will create that vital feeling of distance. This technique of using cooler colours and lighter tones in the distance, warming and strengthening them towards the foreground, is known as aerial perspective. Allow the previous hill to dry before painting the next one or you will get muddy colours and poorly defined hills. A good tip is to wash over the farthest hills with clean water once the paint has dried and dab with a tissue; this removes that hard edge and fades the shape (see Fading colour, page 18).

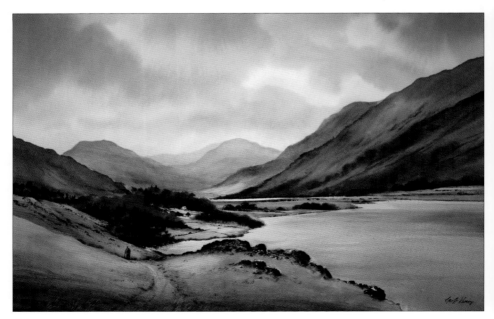

Texture on distant hills

In this example, of Grange in Borrowdale, I have represented the scree on the bare hillside with dry brush work. When working in this way, make sure you use a Rough paper; this was painted on 640gsm (300lb) Arches which has an excellent tooth to it. After the initial dry brush work, I have further developed detail on the hills with a small no. 2 round brush, picking out larger stones and rocks (see Creating texture on hills, page 16). Don't overdo this – remember the hill is in the distance, so should not be too detailed. A good habit to get into is to keep stopping and asking yourself, 'Have I done enough?'

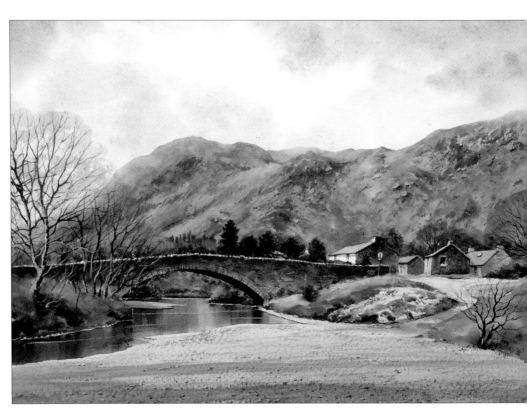

Snow-capped mountains

In order to get this effect, I used masking fluid to define the shape of the top of the mountain. Make sure you apply plenty of masking fluid rather than just a line round the top, as the snow comes well down the slope. I then applied paint using the dry brush technique, ensuring the brush strokes followed the contours of the slopes. I gradually changed the colours from a thin blue/grey, through a darker grey to warmer, richer colours. The dry brush work is mainly for the top of the hill, as

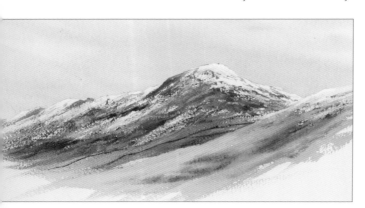

the patches of white left behind represent snow. As you progress down the slopes, use wetter, more flowing washes. You can enhance the white by adding a touch of white gouache here and there, but don't overdo it; the best white is usually the paper. If you add gouache, it should be as a finishing touch, because if you put paint on top of it, it smudges and becomes messy.

Low cloud and mist

Of all the techniques in this chapter, this is the trickiest, but get it right and it is very rewarding. To achieve this effect, paint the sky first and leave it to dry before drawing a pencil outline for the hills. If you paint the sky over the pencil lines, it will seal them in, and you will see a line later on, through the mist. The key to this method is to keep introducing clean water as you paint the hills, aiming for that 'now you see it, now you don't' effect, giving the impression that you are glimpsing the hills through the moving veil of mist or low cloud. See also Creating low cloud and mist on mountains, page 19.

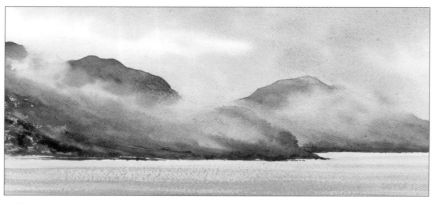

Gentler, rolling hills

In this scene of Peveril Castle in Derbyshire, we are looking at a rolling landscape of gentle slopes, and as the distance mainly features cultivated land in the form of meadows and pastures, a somewhat different approach is required. Always work from the background, progressing through the middle distance to the foreground. Bear in mind that cool colours recede and warmer colours come forward and paint the background with cool greys, gradually introducing yellows, browns and greens. Wait until these background washes are dry before indicating the dry-stone walls, hedgerows and trees that give the middle distance and distance their form. If the fields on the reference photograph you are using are all green, add a touch of raw sienna and burnt sienna as I have done here – it adds a bit of relief and a hint of warmth, as too much green can look a bit flat. When you paint in the dry-stone walls and distant trees, use a fine brush to keep them small, very gradually increasing the scale; this helps with perspective and depth. You do not have to paint them too carefully; in fact it is better if they are rendered with quick strokes so they have a haphazard, more natural look.

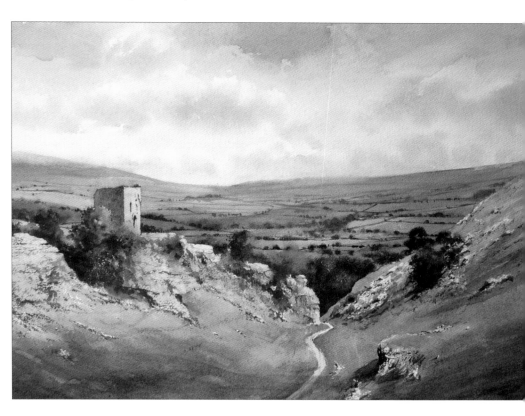

PAINTING TREES

In order to progress in watercolour landscape painting, it is vital to have at your disposal a variety of techniques you can use to depict some of the huge number of shapes and sizes of trees you are likely to find in the scenes you choose to paint. As trees vary according to the season, so do the colour mixes and methods you need to employ to depict these variations convincingly.

In this chapter we will look at some of the methods I use both for individual trees and trees en masse.

Drawing an outline

Before setting about painting any tree, I always pencil in a rough outline of the shape to act as a guideline throughout the painting process. This does not have to be too detailed, just the rudimentary shape will suffice; it is actually better to decide how much detail you wish to include during the painting process, rather than beforehand.

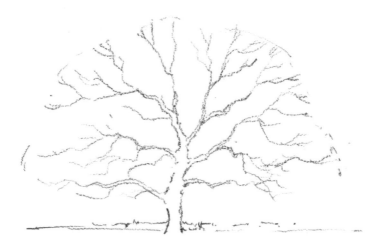

Broadleaf trees in spring and summer

In this example I have used dry brush work to create a broken effect which effectively suggests foliage (see Painting foliage using dry brush work, page 17). For a summer tree like the one in the example, I used two paint mixes: a bright green mixed from aureolin and cobalt blue and a dark green mixed from aureolin, ultramarine blue, and a touch of burnt sienna. To make the colours slightly more spring-like, I would substitute lemon yellow for aureolin in the bright green.

Always paint the foliage first, and then put in the trunk and branches, allowing the branches to appear in the gaps, before disappearing into the foliage. It is important that your branches gradually get finer towards the outer shape of the tree.

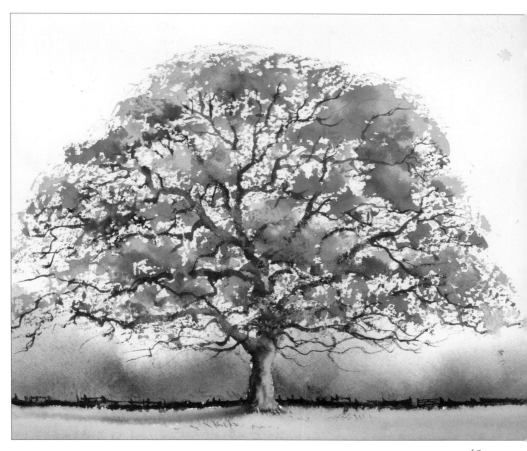

Tree trunks are not always brown

It is important when painting trunks to do a bit of observation. Look at the variety of colours in the bark and observe how these colours are affected by light and shadow. In this example I mixed a variety of colours: Indian yellow, cerulean blue, Naples yellow and a mixture of burnt sienna and French ultramarine and burnt sienna and raw sienna. Once these mixes were prepared, I wet the whole trunk area with clean water and dropped them in, allowing them to mix and merge on the paper, and concentrating the darker colours towards the shaded side of the trunk. Do not overwork this; it is better to let the colours soften and blend on their own, which creates new, interesting shades and helps with the cylindrical shape you need to achieve.

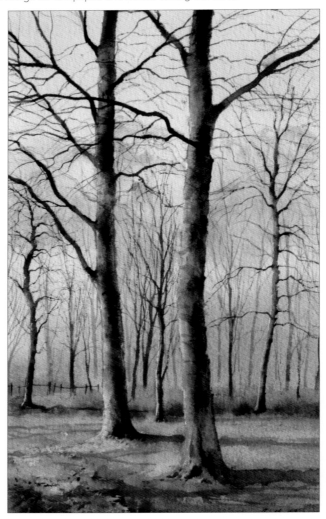

Birches

For this row of birches, depicted at the edge of a forest, I applied masking fluid to the long, thin trunks, using a fine brush to ensure they did not look too thick and clumsy, before painting in the background. When the background had dried, I put in a very thin mix of burnt sienna and raw sienna to represent the tops of the trees and fine tracery of branches. When suggesting the fine branches in this way, ensure that the wash is very thin and use the dry brush technique. Once the masking fluid was removed, I coated one trunk with clean water before dropping in some patches of a rich dark brown made from burnt sienna and French ultramarine. I allowed this dark to soften into the wet background without spreading too far, thus leaving plenty of white paper still visible. It is important when working with this technique to focus on just one tree at a time, otherwise the clear water will dry before you have time to drop the dark brown into it. To finish off the birches I used a fine no. 2 brush to put in the very fine branches with the same dark brown mixture. I also painted a few light coloured branches with a mixture of white gouache and burnt sienna. To make the marks on the trunks look convincing, it is important to get that slightly blotchy, random look.

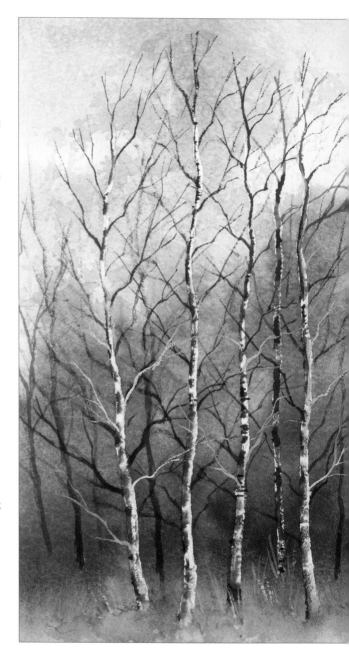

An ivy-clad winter tree

Here I have used the dry brush technique to capture the broken effect of the thousands of ivy leaves that form the trunk's shape. For the ivy I used a rich, dark green mixed from viridian, French ultramarine and burnt sienna, adding a few highlights and a few lighter branches against the dark with Naples yellow. I have also used a very thin wash, as used in the Birches tip on page 51, to define the shape of the tree and suggest the fine tracery of branches that creates the outline of the tree. Remember to paint the fine branch-work with very thin lines, and stop painting them when you reach the outer edge of the previously applied wash, as this marks the outline of the tree.

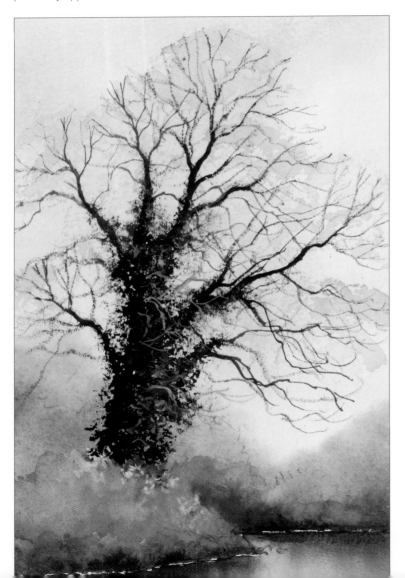

Fir trees

The foliage on fir and spruce trees is much finer than on broadleaf trees, so it has a softer appearance, more suited to the wet into wet technique (see Wet into wet fir trees, page 14). To achieve this, you need to be well prepared and have the foliage colour mixed before you paint the sky; this way, as soon as the sky is painted, you can put the foliage colour into the still wet background. In this example I mixed the same rich, dark green used in the ivy-clad winter tree opposite. It should be a thick paint mix so that it will spread slowly into the wet background.

Another point to consider is that I masked out some of the tree trunks before applying the foliage. This enabled me to achieve the impression that the foliage covers the trunk in parts, allowing just a few glimpses of it here and there.

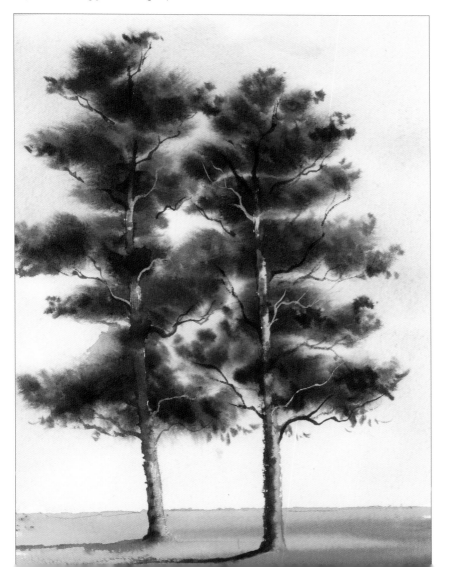

Autumn foliage

To paint a tree in the autumn, you could use the same method as I used for spring and summer trees and just change the colours. I find you can make a good autumn gold using a mix of lemon yellow and burnt sienna or aureolin with a touch of vermilion. For the more shadowy areas of foliage, I use a brown mixed from burnt sienna and French ultramarine. Alternatively, burnt umber will give you a good, rich brown.

An alternative method is to use a natural sponge (see Using a natural sponge for foliage, page 18). Here I have used a variety of orange and brown colours, before adding a few highlights with a touch of lemon yellow. When using a sponge, employ a light touch, and experiment on a piece of scrap paper first to explore the variety of effects you can achieve. Always add the trunks and branches with a brush, after the foliage, as it is easier to see where a glimpse of branch is appropriate, and always ensure that they get finer towards the top of the tree.

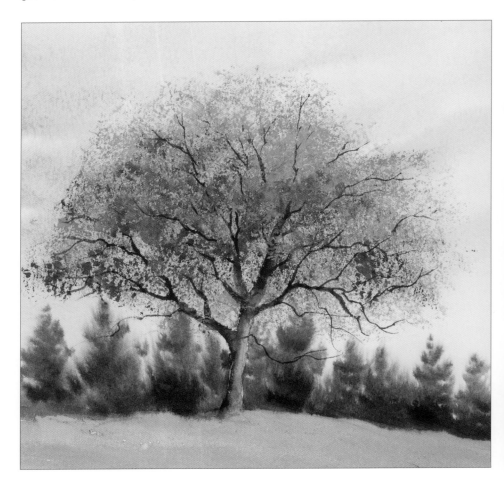

In this example the autumn tree really adds an area of vivid, warm colour to the scene. To achieve this it was important that I had white paper behind it, so I protected the shape of the tree with masking fluid before painting the background. I applied the masking fluid on to a wet background so that I got a soft, almost furry shape of white paper, suggesting foliage. See Masking fluid on a wet background, page 23.

Foliage en masse

Mix your washes first as you will be painting wet into wet: cobalt blue and rose madder as a blue for the sky; lemon yellow; a bright green from aureolin and cobalt blue; a dark green from aureolin, ultramarine and burnt sienna; and raw sienna with a little burnt sienna.

1. Wet the paper with a sponge. Use the no. 16 brush on its side to paint the blue from the top as a glimpse of sky, then drop in lemon yellow.

2. Drop in the bright green, and then the raw sienna and burnt sienna mix.

3. Change to the smaller no. 12 brush so as not to overwhelm the previous colours, and paint the dark green lower down. Allow to dry.

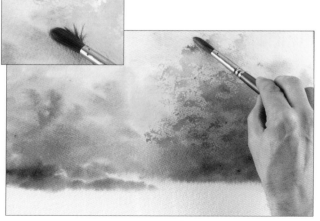

4. Pick up the bright green on a dry no. 12 brush and define the foliage with the dry brush technique. Soften in places with clean water.

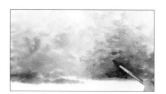 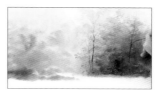

5. Apply raw sienna and burnt sienna with dry brush work, then the dark green in the same way. Blend the dark green by painting a little lemon yellow on top. Allow to dry.

6. Mix cobalt blue, rose madder and burnt sienna and use the no. 1 brush to paint trunks and branches.

7. Use the no. 2 brush and burnt sienna and ultramarine to paint the nearer, darker trunks with thick paint and rapid strokes of the brush. Add fine branchwork with the no. 1 brush.

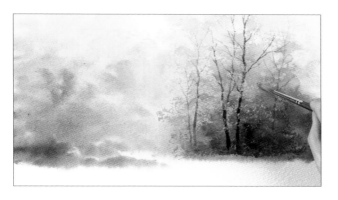

8. Add further dry brush work with lemon yellow and the no. 7 brush, placing this opaque colour in front of the tree trunks.

The wet into wet background, still visible on the left of the painting, has been developed with dry brush work and wet on dry techniques on the right.

PAINTING WATER

Water is a vital ingredient of so many landscape paintings that it is really worth learning to depict it convincingly. The presence of water in a scene takes many forms; it might be a river, stream, lake, pond or even a canal, but in each case it will let down the whole painting if it does not look right.

Whenever I run themed workshops, the subject of painting water is popular with students. I always encourage them to try not to be too literal in their interpretation of the photographic reference, particularly where reflections are concerned. I believe these are always more effective if they are an impression of that which they reflect rather than a perfect mirror image; in fact I hear myself saying over and over again, 'Don't overwork it. If it looks wet, quit while you're ahead'.

I use a variety of techniques to render water, depending on whether it is still, slow moving, disturbed or calm, or even a waterfall with plenty of movement, splashes and foam.

Monsal Head, Derbyshire

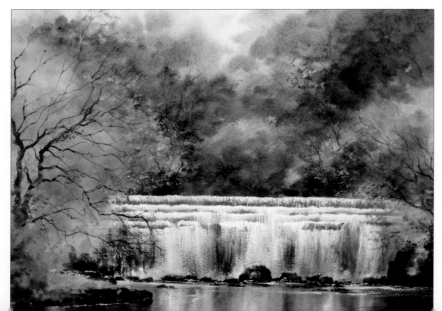

Still water

In this painting, *Kilchurn Castle, Loch Awe*, the surface of the loch is very calm, giving us almost a mirror image of the ruined castle. To achieve this effect, I painted the whole scene above the loch, including shoreline, castle, hills and sky, with a line of masking fluid along the horizontal line where water meets land, to keep it white. I then mixed all the same colours again, before wetting the whole loch area with clean water, leaving a thin line of dry paper where water meets shore. I then brushed in the colours directly under where they appeared above the water line, creating a softer, much less detailed mirror image in the still damp background. I then quickly took a 13mm (½in) flat brush, and using quick, vertical strokes, blurred the paint just before it dried. Finally I put in thin, horizontal lines with a touch of white gouache, to hint at a few ripples.

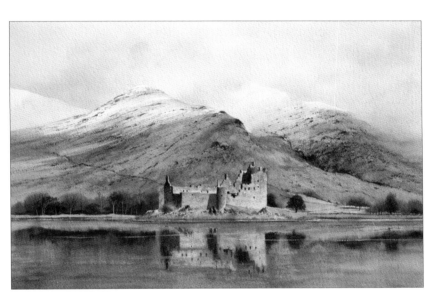

Simpler reflections

The scene reflected in the painting above is quite complicated, and I would not suggest you try this method for the first time on such a detailed subject. However, in this painting, the reflections are rendered using the same method but are of a much less demanding background.

Using masking fluid to create vertical reflections

In this step-by-step example, you can see how vertical reflections are created using masking fluid in several stages to protect the distance and the river banks. Before beginning the sky, mix an orange wash from Naples yellow and vermilion and a grey from cobalt blue and vermilion.

1. Use masking fluid to mask the distant horizon and the water's edge.

2. Wet the sky area and use the no. 16 brush to float in the orange mix at the bottom of the sky, then the grey wet into wet above it, darkest at the top.

3. Use a no. 7 brush and a thicker mix of the grey to paint distant trees on the horizon while the background is still wet. Allow to dry.

4. Apply more masking fluid to the tops of the river banks and allow it to dry.

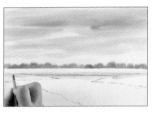

5. Sweep a shadow across the distant snow with the no. 7 brush and cobalt blue with a hint of vermilion. Soften this with clean water, then strengthen it at the water's edge.

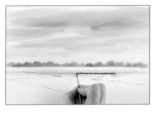

6. Use a no. 1 brush and a mix of burnt sienna and ultramarine to paint dark soil at the water's edge. Allow to dry.

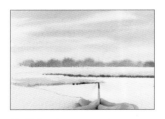

7. Paint the nearer river bank in the same way, with shadow, then soil at the water's edge.

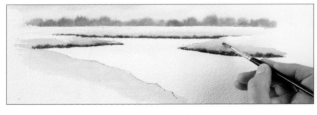

8. Repeat for the right-hand bank and allow to dry. Remask the two river banks and mask the foreground bank with deep layers of masking fluid, so that you can paint the water. Allow the masking fluid to dry.

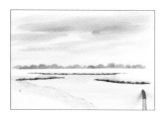
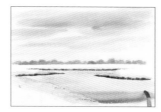
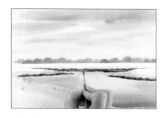

9. Wet the whole water area with clean water using the no. 10 brush. Leave a tiny line of dry paper under the dark river banks. Float in the sky mix of Naples yellow and vermilion.

10. Introduce cobalt blue and rose madder with horizontal strokes, then cobalt blue and vermilion at the bottom.

11. Paint wet into wet reflections of the burnt sienna and ultramarine soil at the water's edge, preserving a tiny white line where you left the paper dry.

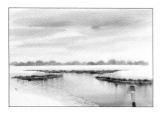

12. Blur all the reflected colours by dragging them down vertically while wet using the 10mm (³/₈in) flat brush. Allow to dry.

13. Remove all the masking fluid and paint a shadow across the snowy foreground with cobalt blue and rose madder, using the no. 12 brush.

14. Sweep a grey mix of cobalt blue and vermilion across the foreground and use clean water to soften it into the white.

The finished painting.

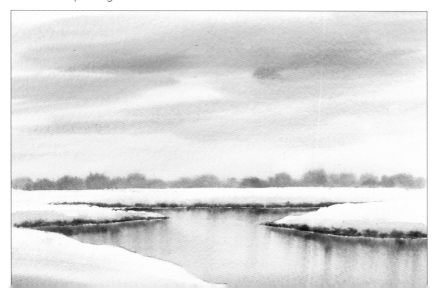

61

Painting a lake using wax resist

Often in a scene depicting a lake or other large body of water, the breeze across the surface causes sufficient disturbance to create the effect of reflection of the sky alone rather than any of the surrounding landscape. The effect of rippled, sparkling water reflecting the sky can be created using wax resist, as shown here, in an extension of the demonstration at the bottom of page 19.

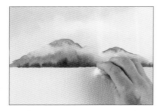

1. Cut a piece of white wax candle or tea light and drag it over the paper with horizontal strokes, to create a sparkling effect.

2. Use the no. 10 brush to paint horizontal strokes of a grey mixed from cobalt blue, rose madder and burnt sienna.

3. Near the foreground, introduce a darker mix of the same colours.

The finished lake.

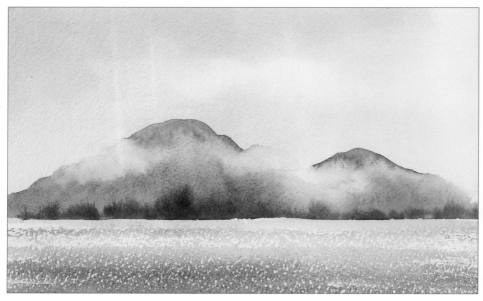

Painting a river using wax resist

Occasionally the surface of the water can be smoother in some areas than others, as in the painting below, where under the bridge the surface is more rippled than the foreground. In this example I have treated the water exactly the same as in the paintings on page 59, but prior to wetting or applying any paint to the river area, I have gone over the paper with a candle to create wax resist, as shown opposite.

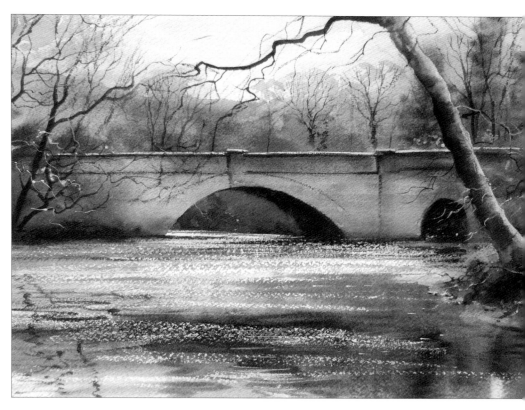

Tumbling water

When painting tumbling water, it is important to leave plenty of white paper to represent the foam, and apply the paint with bold, quickly applied brush strokes to create the feeling of movement. In this step-by-step demonstration, you can see the methods I used to achieve this effect. The painting on page 58 of Monsal Head in Derbyshire was done using the same techniques.

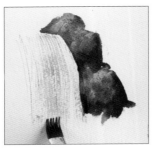

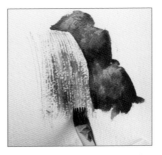

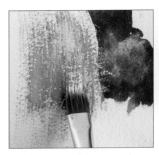

1. The rocks here have already been painted and dabbed with kitchen paper to create texture. Allow them to dry, then use the rake brush to apply a thin wash of burnt sienna and ultramarine with a downward, sweeping motion. Then apply cobalt blue in the same way.

2. Introduce a darker mix of burnt sienna and ultramarine lower down.

3. Use neat white gouache on the rake brush to suggest foam, bringing this over the dark background of the rock in places.

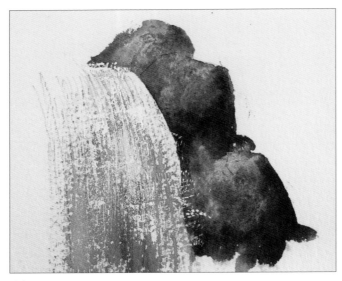

The finished waterfall.

Creating ripples using masking fluid

In this example, *Brotherswater, Cumbria,* I painted a few ripples with masking fluid in the bottom right-hand corner, before painting the water, depicting it with vertical reflections. When applying the masking fluid, use a fine brush, making thin marks that taper at the edges, to represent the shape of ripples. Once you have removed the masking fluid, you can develop these shapes with a touch of gouache.

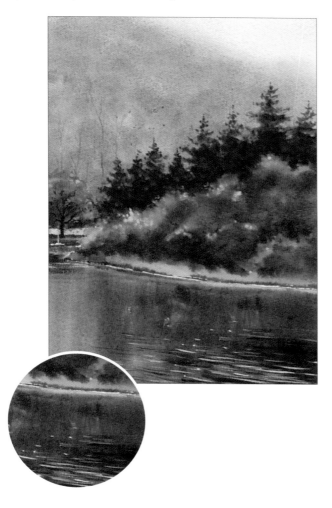

PAINTING BUILDINGS

Buildings and other man-made structures form an important part of my landscape paintings. In the search for good subjects, I am drawn to a whole variety of buildings, from country cottages, through rustic farm buildings, windmills, fisherman's huts and sheds to bridges. The first thing to consider is getting the perspective correct.

Some simple rules of perspective

When it comes to painting, I do not normally like to talk about rules, but without a basic understanding of perspective, it is impossible to make buildings look convincing. This diagram should help you understand some simple principles of perspective. I have indicated the eye level and vanishing points in red.

Remember all parallel lines above your eye level slope down to it, and all parallel lines below eye level slope up to it. As you can see from the diagram, this helps with plotting the position of details like windows, doors and chimneys. This only applies to parallel lines.

You can have as many vanishing points as you need, but only one eye level. Note how the parallel lines of the gable go to a different vanishing point, but it is still on the same eye-level.

The red cross shown on the gable with a vertical line through it enables you to position the top of the roof.

Remember that the underlying shape of the building is a simple rectangular box, as with most buildings. When faced with a complicated building, look for the box shapes within it.

A good tip for finding the eye level if you are working from a photograph is to draw the lines on the picture with a ruler and pencil. Wherever they converge, that is your eye level. Always ensure that this eye level line is truly level.

Always check your perpendicular lines. If they slope, it can make the building appear as though it is suffering from subsidence.

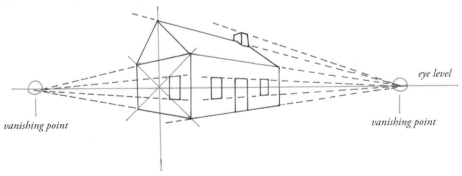

eye level

vanishing point *vanishing point*

Making the buildings a focal point

In this example, the farmhouse and cluster of barns and sheds form a vital focal point. Try to visualize the scene without the buildings – I think you will agree it would not be as attractive a composition. It is a good idea to make one of the buildings a real focal point by giving it the maximum contrast with its surroundings. This is why I particularly liked the way the whitewashed walls of the farmhouse contrasted with the dark shadows on the hills behind. A path or track to lead the viewer's eye from the foreground to the focal point is a good idea. Always observe the direction of the light and make maximum use of shadows to make the buildings appear hard-edged and three-dimensional.

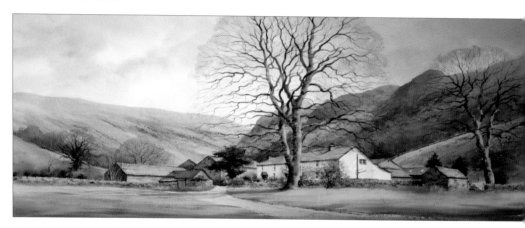

Weathered sheds and huts

In this scene at Port Mulgrave on the Yorkshire coast, I particularly liked the juxtaposition of the old huts and sheds; it gave me the perfect opportunity to explore the variety of shapes, colours and textures in the woodwork and corrugated iron. When painting a scene like this, be bold with colour, slightly exaggerating the blues, greens, reds and browns. Don't paint it too painstakingly, instead use rapid, confident strokes, allowing rough edges and broken lines to describe the weathered look. For the texture in the corrugated iron I used a rake brush and dry brush work, as for the weathered wood on page 20.

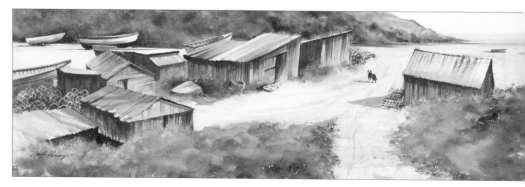

Painting a windmill

A windmill like this one at Cley in Norfolk presents us with a different challenge, namely to make it appear cylindrical. The way to achieve this is to paint it firstly with the red-brick colour, raw sienna and burnt sienna. Once that is dry, put the shadow colour in, painting it from the edge towards the centre, gradually introducing clean water so that the shadow fades into the colour underneath. Remember, to describe a curve, the shadow has to gradually fade, rather than stopping at a line, which would look like a corner. Put a strong sky behind a subject like this to give it some punch and take advantage of the colour contrast of the warm orange/red brickwork and cold blue/grey of the sky. These colours are opposites and really bounce off each other. I used masking fluid to put in the sails before painting the sky, later adding some shadow and a few finishing touches with white gouache.

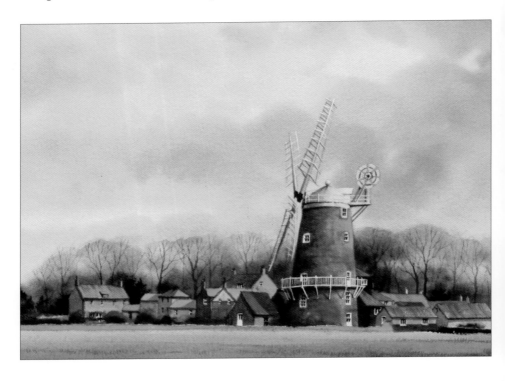

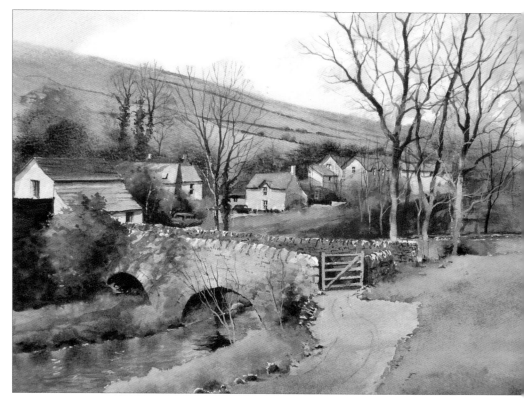

Painting a bridge

It is important with a subject like this to make the bridge the focal point, and to convey the thickness of the walls and sheer strength that has kept it standing, probably for several hundred years. Always observe the scale by comparing the height of the arches with the depth of stonework from the top of the arch to the top of the bridge. Don't be afraid to paint the shadowed underside of the arches with a rich, dark colour, French ultramarine and burnt sienna, to give a good contrast with the light on the stonework. Add a touch of red/brown (raw sienna and burnt sienna) to give the impression of some warm, reflected light. When you can see the far wall of the bridge, as in this case, you can make this look convincing by putting shadow on it to contrast with the light on the front wall. Don't overwork the stone detail – you only need a few suggestions of cracks and crevices here and there.

Simplifying what appears to be a complex shape

If we look at the painting opposite, it can appear to be quite a complex, detailed subject, probably a bit daunting for the beginner. However when you look at the drawing below, it does not look anything like as complex, because I have broken it down to basic line and shape. When starting out with a new painting, take time to look at the subject and ask yourself, what are the underlying forms and shapes? Once you have got these in place with a rough pencil line, the whole project becomes much easier.

Use a ruler! Not only does it help to keep lines basically straight, but you can also measure different aspects of the building to compare ratios: for instance how many times does the height of the chimney go into the height of the house, or how many times does the width of the window go into the width of the wall. Ratios are very important to help you to judge size and scale. For instance, if you paint the windows too large, it alters the whole character and period of the house.

If you do rule any lines, make sure you loosen them up a bit before painting, or it might look more like a technical drawing.

The details of the painting opposite are discussed on pages 72–73.

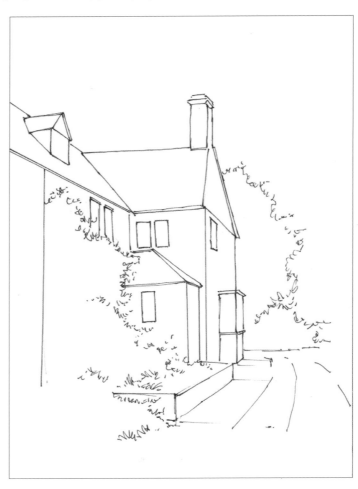

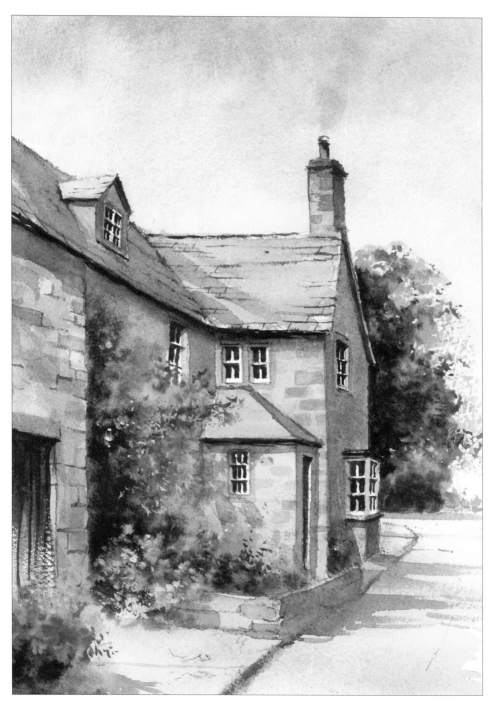

71

Building details

These details are taken from the painting on page 71.

Windows

When depicting windows, paint the dark behind the pane of glass, leaving the remaining white paper to represent the casement. Notice that at the top left of each little pane, I have added a small triangular shape of dark paint on the frame; this indicates the angle of the light. Also note the shadow along the top of the casement and down the left-hand side; this gives the impression that the window is recessed – if you don't do this, the window could look hung on the wall rather than set back. Make the shadow from the overhanging eaves shade the top of the window frame.

Roof and chimney

Make sure you include a shadowed side to the chimney to keep it looking three-dimensional. That little ridge of tiles just below the top also makes it convincing. Note how the shadow on the chimney pot is softened into the main colour to create that cylindrical effect. I put in the smoke by re-wetting the sky above the pot, then brushing in a subtle grey wash, allowing it to soften into the wet background.

To paint the roof, I brushed in three washes: the sky colour followed by the stone colour and finally a touch of green to hint at a bit of moss. When these had dried, I suggested a few crevices between the tiles with a bit of dark brown on a fine no. 2 brush. Don't overdo the crevices – all you need are a few suggestions here and there.

A bit of garden

I have used lemon yellow plus a bright and a dark green with a few touches of white gouache dropped into the still wet green to suggest flowers. You can add a touch of colour (rose madder in this instance) to the gouache to suggest a variety of flowers. Try to paint the greenery in while the wall is still wet to give that soft foliage effect. If the wall has dried, just re-wet it.

The doorway

The door represents an opportunity to add a different colour; in this case I have used a rich mahogany red mixed from burnt sienna and rose madder. Paint this in rapidly to leave a bit of untouched white, thus adding texture. If you do not paint a subject like this loosely, with rapid brush strokes, it can look like a chocolate box lid. As with the roof, it is more effective to paint just a few suggestions of mortar between the stones rather than overworking the detail.

The whole painting.

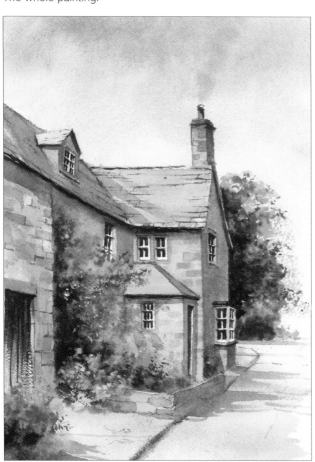

Dormer window

Small details like this are always better included as they add that bit of authenticity. You might think this is tricky to draw, but it is not if you treat it as a smaller version of the gable, carefully observing how it is set into the roof. Observe the contrast created by the shadow on the main roof and the light on the dormer roof. Again just a few suggestions of gaps between the tiles are sufficient.

PAINTING COASTAL SCENES

I never cease to be inspired by visits to the coast, whether I find steep cliffs, busy harbours, small fishing villages, or long stretches of sand and rocks, and I am always on the lookout for a good vantage point or a slightly less conventional view.

Concentrating on the foreground

We are looking up at the scene in this painting of Boggle Hole on the Yorkshire coast, so the sky occupies less than a third of the paper, giving us plenty of foreground and middle distance. I chose this viewpoint because I particularly liked the cluster of rocks and the reflections in the rock pools. I used the diminishing shapes of the rock pools and wet sand to lead the viewer's eye to the buildings at Robin Hood's Bay, resting on the horizon line. Note how I have tried to create the effect of shallow water by giving the rocks in the bottom left both a shadow and a reflection (see close-up).

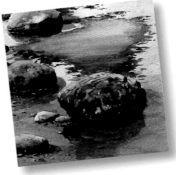

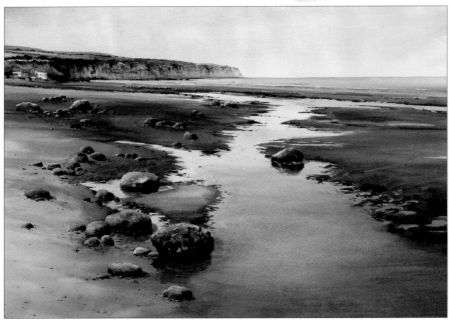

Scratching out beach textures

A good tip for giving the illusion of small pebbles and stones in the foreground is to scratch these out with a sharp craft knife as shown.

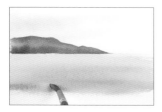

1. Paint the beach down to the foreground with raw sienna on the no. 12 brush, then while this is wet, paint burnt umber and raw sienna lower down.

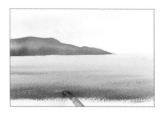

2. Add ultramarine to the mix and paint this dark wash wet into wet in the foreground. Allow to dry.

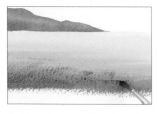

3. Use the no. 7 brush with burnt umber and ultramarine and the dry brush technique to create texture in the foreground. Allow to dry.

4. Chip out a few marks with a craft knife to suggest little stones.

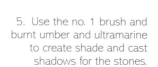

5. Use the no. 1 brush and burnt umber and ultramarine to create shade and cast shadows for the stones.

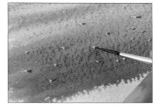

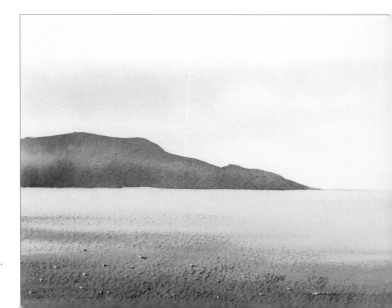

The finished beach.

Look for a good vantage point

This is a very different viewpoint from the Boggle Hole painting on page 74;
to get this scene (Portloe in Cornwall), I climbed up a cliff path and looked
down into the bay. This gave me an excellent composition, with the cluster of
whitewashed buildings just to the right and slightly above the centre. If you are
featuring whitewashed buildings, always mask out the shapes before painting the
background, because preserved white paper is always brighter and cleaner than
white gouache. Observe how I have painted the distant trees in a misty, soft tone,
gradually strengthening the colour and tone towards the foreground. Use every
opportunity to explore the contrast of hard and soft edges; there are plenty of
examples in this painting.

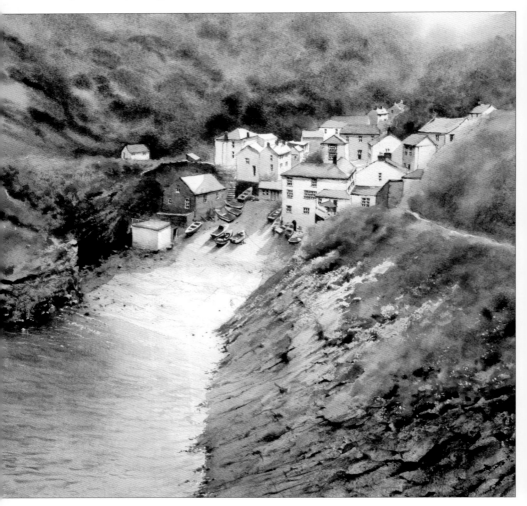

Coastal detritus and boats

When looking for a potential painting, I am drawn towards slightly untidy, undeveloped and neglected subjects like this, *Port Mulgrave, Yorkshire Coast*. Don't exclude items like the old tractor, abandoned lobster pots and rusty sheds – they are useful features for artists and you can use them, as I have here, to create a feeling of distance by making them get gradually smaller, leading the viewer along the beach and into the distance.

Many modern boats are made of fibre-glass but I prefer the old clinker-built type. The main boat here was modern but I have used a bit of artistic licence, suggesting the timber construction with a few fine lines.

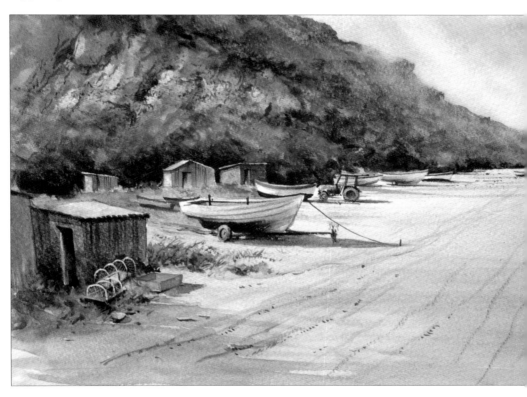

Creating contrasts

The painting above is all about contrasts between warm and cool, light and dark. As a rule of thumb, reds, oranges, yellows and browns are warm; blues and greens are cool. Look for areas of maximum contrast like the light on the roofs of the sheds, and the white of the boat hulls offset against the dark greens behind. This helps to infuse the painting with bright light, depicting a warm sunny day.

Painting boats

Getting the shape of a boat right

Many people are frustrated by their inability to 'do boats', because the shapes are not easy to master. Unfortunately I have not found a gimmick or shortcut to good boats; you should take every opportunity to observe and practise drawing them. Here are a few tips that might help.

Compare the length with the depth and width; for example, how many times does the depth go into the length? If you are working from a photograph, a ruler will help. If you get these ratios wrong, a rowing boat can end up looking more like a bath tub.

Always check that details like seats are at right angles to the hull.

Ask yourself; is the bow higher than the stern? It usually is, but by how much?

I came across this little scene when walking along the sea wall in Amalfi. If you find it difficult to get the right shape of the boat, try starting with a simpler shape, from which you can work out the boat shape. As you can see from this diagram, I have taken a rectangular box (which is easier to draw) as a starting point, and then indicated a straight line through the middle, lengthwise, and a few straight lines, crosswise. This has made it simpler to plot the bow, stern, seats and many other interior details.

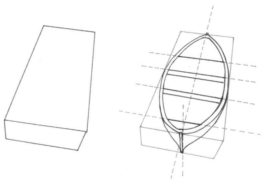

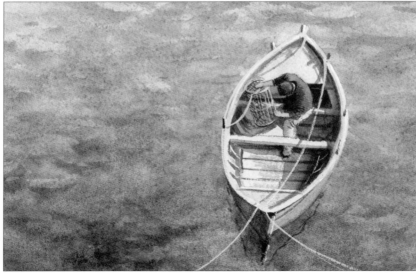

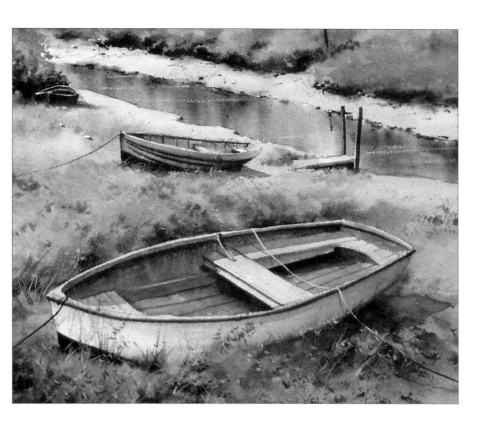

This boat was constructed using the same method.

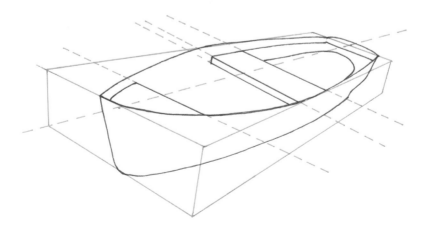

Painting boat details

In this painting, *Beached Boats at Staithes*, I am looking down into the scene, which gives me an opportunity to explore the interiors of the beached boats. I actually prefer beached boats to floating ones, as I like the variety of angles created by the leaning hulls, some sinking slightly further into the sand than others. Always look for small details like the crisscross of ropes leading from the boats in all directions. Paint these with a very fine brush, employing a rapid stroke, using white gouache (sometimes tinted with watercolour) when crossing a dark area, and changing to a dark mix when the rope passes over a light area (see close-up). Vary the colours on the hulls and think about how you can use these colours plus details like stripes to introduce contrast.

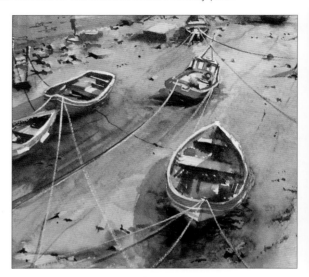

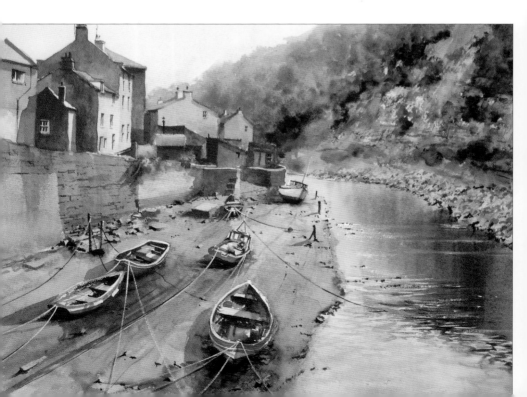

Painting boats sinking into the sand

The boat here is tilted towards us to give the impression it has sunk slightly into the sand. This impression is reinforced by the grasses and sand around the base of the hull, which soften into the dark pitch colour. To achieve this, you should paint these while the dark colour on the boat is still wet. However if you cannot get to it quickly enough, wait until the hull is dry, then rewet it before touching in the green and the sandy colour. Lemon yellow was used for suggestions of grass against the dark brown of the hull. Consider how shadow will affect the shape; notice here the light is coming from the left so I have put a hint of shadow on the right and a cast shadow leading from the bow across the sand.

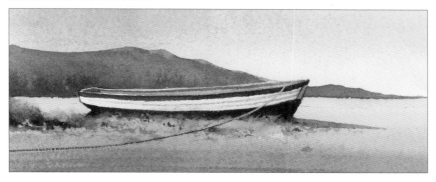

Boat reflections

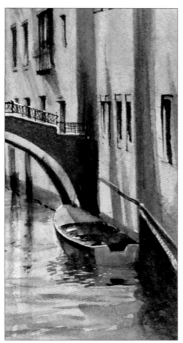

The way I treat the reflections from a boat depends on the surface of the water. Make careful observations from your reference material; if it is still water with an undisturbed surface, the reflection will almost be like a mirror image. More often than not though, as you can see from the example, left, the reflection will be disturbed by movement in the water. When considering this, observe the different colour of the shadowed area of the boat and ensure this is echoed in the reflection. Make sure your reflection colours accurately mirror the colours of the boat itself. Use a fine brush so that you can break up the shape of the reflection, leaving a few gaps to represent the way the light catches the ripples.

PAINTING SNOW SCENES

I really enjoy painting snow scenes; I think it is because I am attracted to the simplifying effect of the white cloak across the landscape. I like the way the sky colours are echoed through the thin shadows, contrasting with the rich winter darks of trees and hedgerows. We all know that snow is white, but as you can see from the following examples, there are numerous techniques and colour schemes you can use to depict its effect on the scene in front of you.

Don't be afraid to use colour

Just because it is winter, it does not have to be all grey and brown, and it does not have to make you shiver when you look at it. In this painting, *Ashford in the Water, Derbyshire*, I have used a variety of colours: greens, oranges and browns, plus a warm purple tint to the sky and shadows, giving the effect of a bright, winter's day. Before starting your painting, always take a bit of time to observe the scene, looking for opportunities to add colour, and exaggerate the colours if you think it will improve the result.

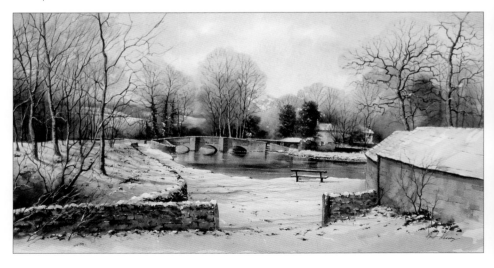

Snow-covered distance

Always echo the sky colours in your shadows: in this instance I have run thin washes of the blue and grey from the sky across the landscape, taking care to leave a few glimpses of pure white paper. Leave this to dry before starting on the details.

When you put in the details, for example distant trees, hedgerows or walls, paint those farthest away with very fine lines and marks, using virtually the same grey as the sky, gradually making the marks larger and darker as you progress towards the middle distance. I have started here with a very vague suggestion of trees on the left of the horizon. As these details get closer, add some burnt sienna to the grey mix to darken it and create a slightly warmer tone, before adding a few indications of details such as fence posts and bushes. You can use a few touches of white gouache on the nearer details to suggest a touch of snow-capping.

You can soften some of the shapes of trees and bushes by wetting the small area of paper they will occupy beforehand, with clean water. Don't make your distant walls or hedgerows too neat and tidy by painting them in straight, rigid lines. The fields should vary in size and shape and look a bit haphazard.

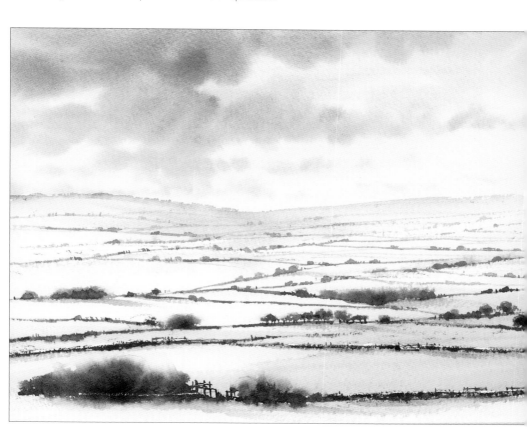

Using silhouettes and a limited palette

The painting of Ashford in the Water on page 82 represents a clear day with the light on the subject, but this one of Chatsworth Park is very different. Here we are looking into the light, which reduces much of the detail to silhouettes. When tackling a subject like this, always use a limited palette. Here I have used just four colours: cobalt blue, neutral tint, burnt sienna and rose madder, which gives the scene simplicity and harmony. To suggest looking into a milky, weak sun, leave a roughly round area of the sky as clean paper with a hint of red (in this case rose madder) surrounding it. To get the 'over-exposed' look to the branches with the sun behind them, paint them normally, then once they have dried, brush over them with clean water and dab with a paper tissue until they fade. This technique requires a light touch or you will wash them out completely (see Fading colour, page 18). Paint the middle distance wet into wet to achieve the soft misty shapes, reserving a rich dark brown (burnt sienna and French ultramarine) for the large silhouetted trees.

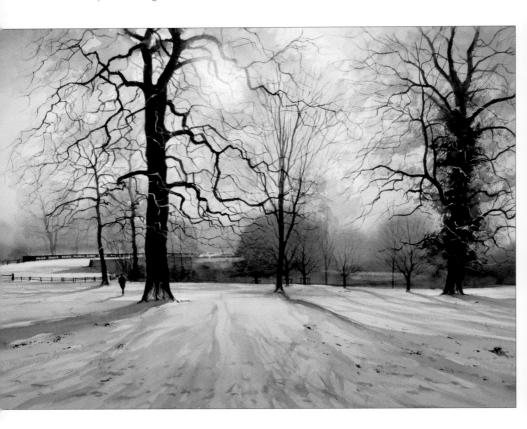

Putting in a warm glow

If you put a warm glow into the sky, of the kind you might get on a late winter's afternoon, then complement this with the same glow on the snow. In this painting of Lumsdale, Derbyshire, I used a wash of vermilion in the lower part of the sky, applying the same wash to the pond area and foreground. Remember this is a tint, so don't make it too strong. Experiment with colour, don't just stick to ones you feel comfortable with. Here I have used a combination of cerulean blue and cobalt blue for both the sky and the shadows. Note the touch of white gouache to suggest snow on the bark of the foreground tree. This can be very effective, but don't overdo it. I used masking fluid to preserve the contrast of the snow-covered bank with the reflections in the water (see pages 60–61).

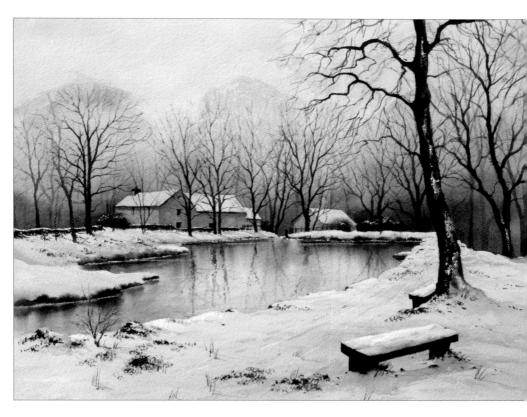

Contrasting hard and soft shapes

A sprinkling of snow perfectly highlights the hard and soft shapes in a landscape. Use masking fluid to pick out harder shapes such as roof tops, the edges of fields and the tops of walls, before painting in the background with misty, amorphous shapes, using the wet into wet technique.

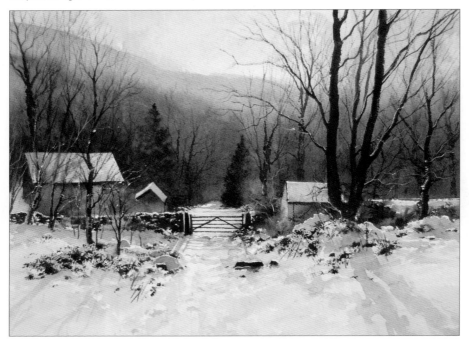

Use the dry brush technique

You could spend lots of time painting details like bracken, twigs and tufts of grass sticking up through the snow, but the most effective way to render these is with a light touch across the paper, with a stiff mixture of dark paint on the brush (see Dry brush work on snow, page 17).

Use shadows on snow to indicate the nature of the ground

Always use the shadows to describe the land on which they are cast; in this case I have made the shadow shapes bumpy and uneven to suggest the uneven nature of the ground. This is particularly noticeable in the shadows from the five bar gate (see close-up) which are much more uneven than the lines of the gate itself. Also in the close-up, note the very thin line of white, providing a highlight on the top edge of the shadowed stone.

Using tinted paper

For this painting, *Evening Light, Froggatt Woods*, I chose a sheet of tinted paper. There are a variety of these on the market, and this one is a very light brown or beige. From time to time it is interesting to try something like this as it makes you think about your approach to the subject. The main difference is you no longer have white paper as your lightest tone, so you need to experiment with a white body colour for the highlights. This can be acrylic, but I prefer gouache as it is removable. You can see the basic colour of the paper from the close-up (right), so anything that appears lighter than this is the result of using white gouache. Use tinted paper when you want to do a slightly darker, more evening picture; it can look rich in atmosphere and really wintry. I used the white gouache to suggest the last of the day's sun and the snow on the distant fields, the silver birches and the foreground rocks and stones.

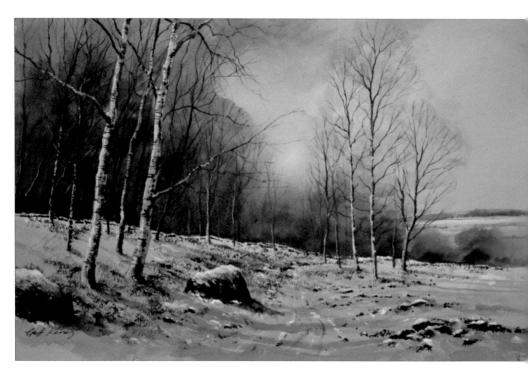

ADDING SIGNS OF LIFE

It is often a good idea to include glimpses of man-made objects and of everyday life in a landscape painting, as it can help involve the viewer in the scene. The inclusion of people, animals, cars or telegraph poles can increase the work's authenticity, imbuing it with a feeling of familiarity. This can also lend a sense of scale and perspective to the scene, even providing an opportunity to introduce a man-made colour that occurs nowhere else in the painting, like the colour of a car or the coat worn by a walker.

Adding animals

In this painting of Chatsworth Park, the deer gathered under the tree form an important focal point. Imagine how different it would look without them. Even though they are just silhouettes, when you include details like this, you should use a fine-pointed brush and make sure you get the shape right.

Adding birds and other elements

Look at this painting of Sea Palling in Norfolk. As with many Norfolk scenes, I chose to make the composition two-thirds sky, but I have used the perspective provided by the line of telegraph poles and the two flocks of gulls to break this up and provide a bit of extra interest. If you are adding birds to the sky, don't just paint a simple 'V' shape unless they are in the far distance; instead, observe the actual shape and avoid making them look clumsy by using a very fine brush to get the points at the end of the wings. The scale is also important; don't make them too big.

This could be a rather desolate-looking scene were it not for the dog walker, the cluster of old weather-worn sheds and the caravan in the middle distance.

Adding contrasts in colour and tone

In this example, note how the bright red phone box contrasts with the rich dark green behind it. Don't just look for a contrast in colour when adding a man-made item to the landscape; try and create a contrast in tone as well.

Adding cars

The same principle of a contrast of colour and tone has been used to render the car here. Notice how the smaller cars down the hill are just simple shapes. When painting cars, don't include too much detail – a convincing shape is much more important. Leave some white paper for the roof to suggest the metallic reflection.

What if there are no signs of life?

I don't believe that every scene is improved by the addition of signs of life, and in many of my paintings I choose to leave the scene uncluttered and quiet. It all depends on whether you feel that the inclusion of people or other signs of life adds to the composition or detracts from it; only you, the artist, can decide that.

The scene you have chosen to paint may not have the signs of life you would like to include, so I think it is important to have a source of small drawings and sketches that can be used to add a bit of extra interest to your paintings. Carry a sketchbook and use any available opportunity to do little thumbnail sketches of people, animals and other elements. Here are a few examples from one of my sketchbooks showing this type of source material.

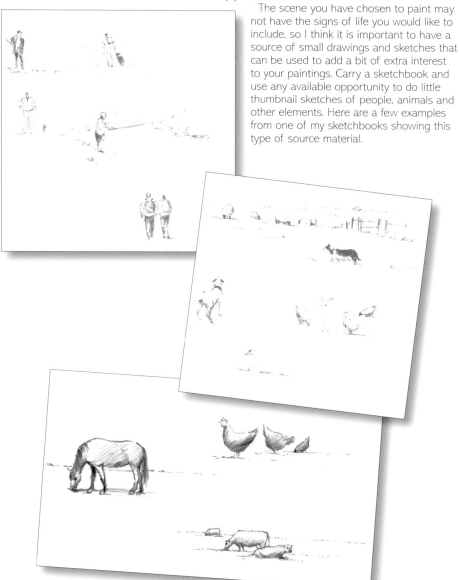

How to add figures to an otherwise completed painting

When working on a painting, you don't always have to decide at the outset whether or not to include figures. In this example you can see how you can take a finished painting and add a figure to it using tracing paper.

1. Draw a figure on tracing paper and move it about over the painting until you find the right place for it. Mark the base of the figure on the painting with a pencil, under the tracing paper.

2. Place the tracing paper on a surface suitable for cutting and use a craft knife to cut out the torso area, creating a stencil.

3. Place the tracing paper stencil back in position on the painting and use a damp, clean sponge to lift out paint through the hole.

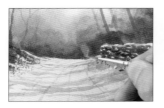

4. Paint the figure's jacket with a mix of vermilion and lemon yellow on a no. 1 brush.

5. While the jacket is wet, paint the shaded side with cobalt blue and vermilion.

6. Paint the head and legs with tiny marks of burnt sienna and ultramarine.

7. Paint a cast shadow with cobalt blue and vermilion.

The finished painting.

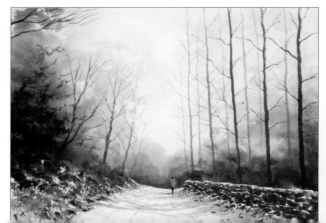

Using figures to create a sense of scale and contrast

In this example, of Cheedale in Derbyshire, the figure gives us a sense of scale, emphasizing the height and sheer size of the overhanging rock. Also note how the figure's orange jacket is an excellent contrast to all the greens and blues that surround it. Look at the painting. Are you drawn to the figure and therefore involved in the picture?

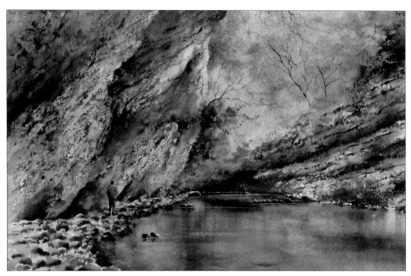

Adding a touch of narrative

You can see from this painting, *Peak District Farm*, that it is quite a lonely, bleak-looking setting with a real feeling of a wintry afternoon. The inclusion of the dog adds to this atmosphere. The viewer can almost imagine that the dog is patiently waiting for its master to return, thus providing the scene with a narrative. In fact the woman who bought this painting said she used to have a dog just like this and that is what drew her to the scene. Who knows, without the dog, it might still have been hanging on my wall.

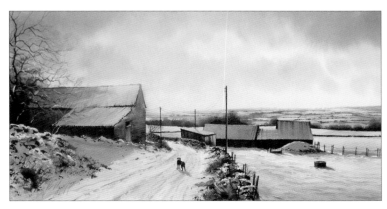

When are figures essential?

In this example, *Port Patrick, Scotland*, it is interesting to note how vital the few figures and the dog are. Compare this with the version of the painting where they have been removed!

When the figures are an intrinsic part of the scene, I always draw them in at the outset and protect the shapes with masking fluid. When masking out figures, apply the masking fluid with the same care you would employ to apply paint; if you don't take care, when you come to remove the masking fluid later, the figures may bear no resemblance to the shape you envisaged.

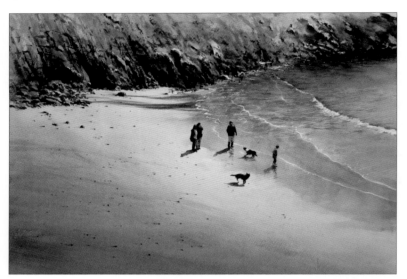

Figures and perspective

In this painting, *Beach at Old Hunstanton*, note how I have used the diminishing size of the figures to create a feeling of distance. Using figures is a very good method to achieve this but it is important that all the heads are more or less on the same level, no matter how far away the figures appear. The theory behind this is explained in the drawing below.

When giving figures the appearance of walking, paint one leg shorter than the other so it appears slightly further away; if you make both legs the same length, the figure may appear rooted to the spot. Look at the large figure on the right and note the slight gap between the right foot and the shadow; this gives the appearance that the foot is off the ground and helps create the impression of movement.

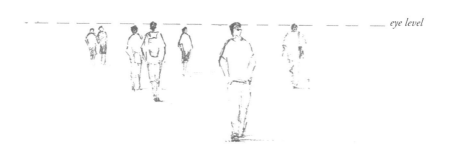

eye level

INDEX